CW00548584

FOLKESTONE'S DISAPPEARING HERITAGE
THROUGH TIME
Pam Dray

AMBERLEY PUBLISHING

*I dedicate this book to my husband Bronco
and also our children Karen, Jon and Donna*

First published 2011

Amberley Publishing
The Hill, Stroud
Gloucestershire, GL5 4EP

www.amberleybooks.com

Copyright © Pam Dray, 2011

The right of Pam Dray to be identified as the
Author of this work has been asserted in accordance
with the Copyrights, Designs and Patents Act 1988.

ISBN 978 1 4456 0290 5

British Library Cataloguing in Publication Data.
A catalogue record for this book is available from
the British Library.

Typeset in 9.5pt on 12pt Celeste.
Typesetting by Amberley Publishing.
Printed in the UK.

Introduction

Seeing various buildings that were being pulled down in the viaduct area of Foord Road, Folkestone, Kent, I felt compelled to write about and photograph our disappearing heritage. I have lived within a stone's throw of the viaduct for most of my life and felt this part of Folkestone has not had much written about it. On this note I set off to do just that, recording the changes in the shadow of the viaduct.

It is amazing to think that the viaduct, built under the guidance of engineer Sir William Cubitt, was started and finished within three years and by all accounts operational by 1843. Trains ran from London to the Junction Station in Dover Road (this being built before the Central Station, which is now Folkestone's main station). At the time, the Junction Station was more convenient for passengers en route to the continent. They would alight at the Junction Station and either walk or get a carriage down to Folkestone Harbour Station. When the branch line was built, the train would go right into the Harbour Station so the passengers could get straight onto the cross-channel ferry to Boulogne.

Naturally, the coming of the railways also meant that Folkestone grew rather rapidly from a small fishing community to a town expanding with buildings all over the place to take the influx of people. During that time there was some unrest from the locals at the amount of workmen employed in building of the viaduct who came from all over England, causing mayhem, getting drunk and fighting in the public houses.

While trying to discover tales relating to the viaduct when it was being built, I came across the following amusing tale. The weather was very rainy and wet, the ground was muddy and like a quagmire. A horse and cart was trying to pull a load of bricks under one of the arches and it got so badly stuck that the workmen couldn't get the horse or the cart out, so they were both left there, and today it is rumoured that they still lie beneath one of the arches. It has been said

that on a dark, cold, windy night you can hear the horse whimpering; but we all know how the wind whistles through the arches!

Like other areas in Folkestone, this place has had its share of unpleasant happenings: fatal road traffic accidents, two murders and suicides, one being a young man who thought he could fly and jumped off the viaduct onto the Foord Road. The rail company have since put extra wire fencing on the edge of the parapet wall of the viaduct to try and stop any more such actions.

Hopefully, by the end of this book you will see some of the changes which have taken place over the past sixty years in the shadow of the viaduct and which I have recorded for posterity.

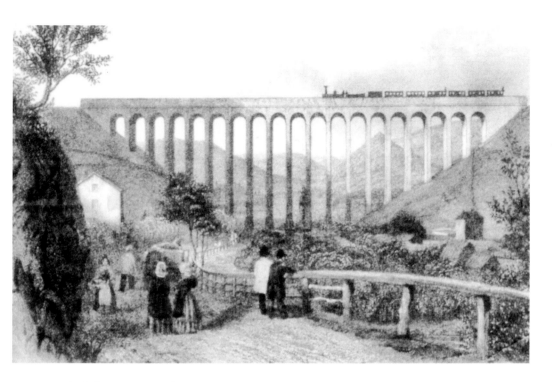

Foord Viaduct, 1850s and 1920s

The top photograph shows the Foord Viaduct in about 1850; note the absence of houses in the area. Although close to the town in the 1850s, the viaduct appeared to be in the countryside. The bottom photograph shows a steam train going over the Foord Viaduct in the 1920s. By this time the whole area had been built up and no sign of the countryside remained.

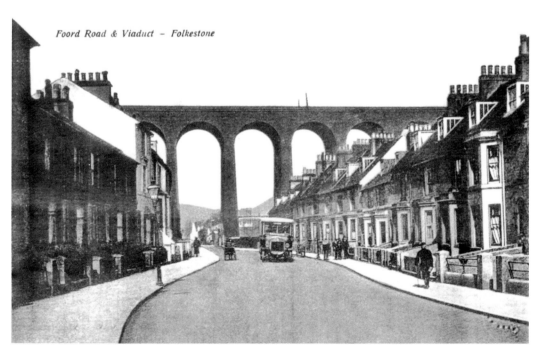

Foord Road & Viaduct – Folkestone

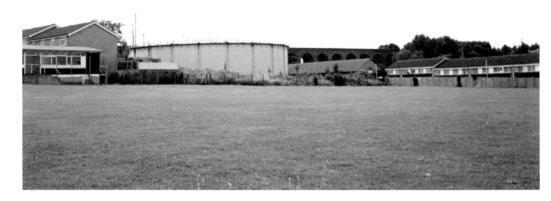

Shepway Close Field with Gas Holder

The top view is of the gas holder from Shepway Close, taken in 1999 before demolition to make way for the building of houses and flats. In September 1999, a leaflet was distributed to houses in the area from a demolition firm called Syd Bishop explaining the demolition of the gas holder and clearance of the debris. In the bottom photograph, the author's grandchildren are shown in the lower part of the gas holder during its demolition; the picture was taken to show the enormity of it, even though it was almost demolished.

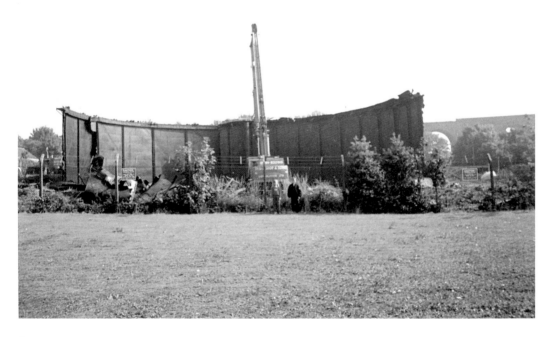

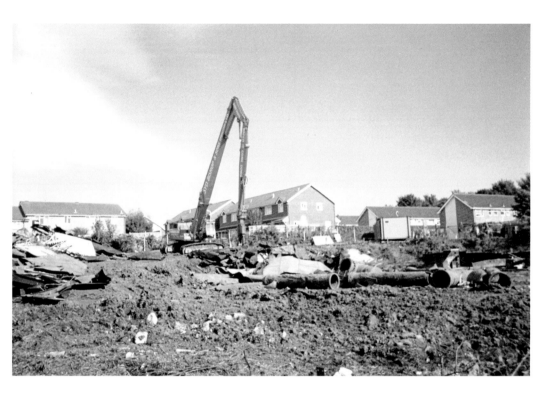

Demolition Taking Place

These two pictures show different stages of demolition of the gas holder, revealing the houses of Eastfields Estate. Having seen the gas holder there all my life, I found it very strange to see it being demolished and, when it was gone, the large open space.

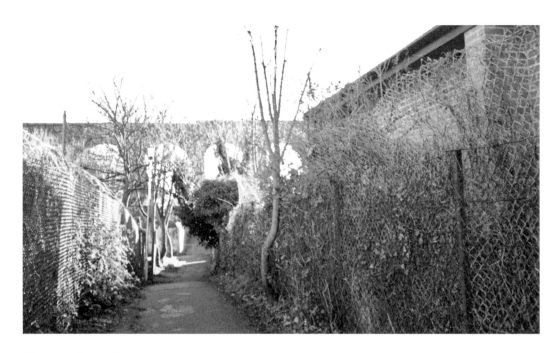

Shepway Close Alleyway

This alleyway, leading from Shepway Close to the viaduct, has a narrow pathway. In the 1950s the area had its own resident tramp called Ted Hart. He was a harmless old man and didn't bother anyone. He carried all sorts of items about his person, including newspapers, a kettle, a paraffin stove, a large rucksack on his back and pots hanging off his walking stick. Sadly, a few years later, the local paper reported that 'an old tramp was beaten up by soldiers' and he later died in hospital. The picture below shows the alleyway in 2011 with flats to the left and a scout hut on the right.

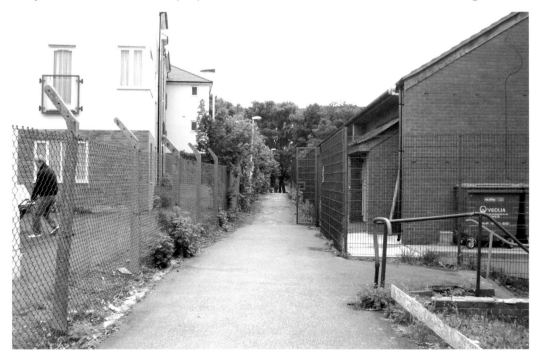

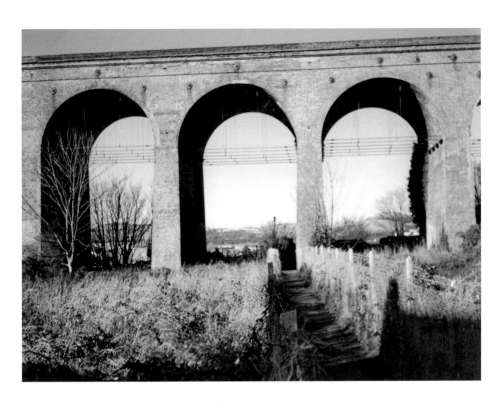

Mount Pleasant Road Side of the Viaduct

These views are of the Mount Pleasant Road side of the viaduct, taken from the alleyway before and during refurbishment. In the spring of 2000 the Impact Folkestone Project decided that the area around the viaduct alleyways was in need of landscaping (it had always been overgrown and untidy). As you can see, the area was in need of a good clean up.

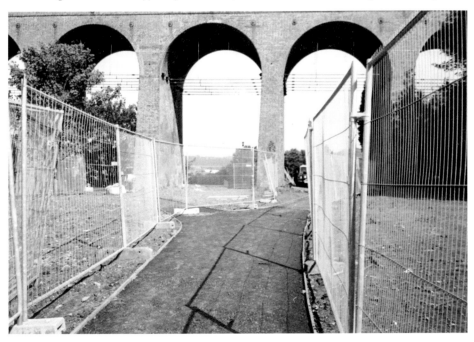

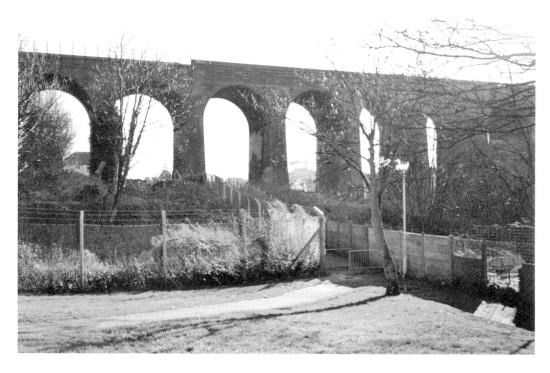

Shepway Close Side of the Viaduct

This fenced-off area continues from the other side of the viaduct, showing how much land belonged to Network Rail. In the photograph below, the workmen for the Impact Folkestone Project are starting to clear inside the railway land, which has now been acquired for the benefit of the local people.

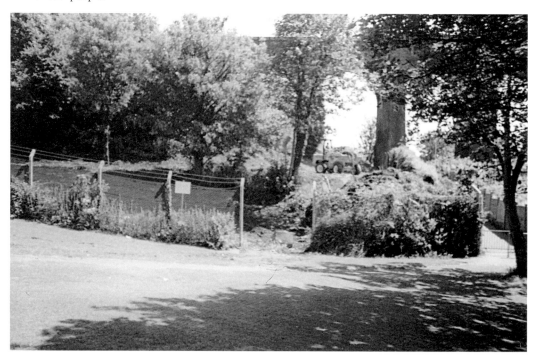

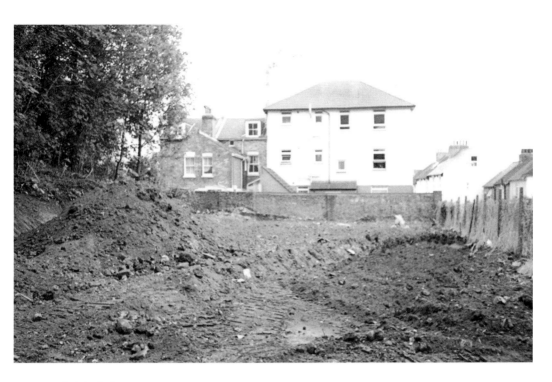

70 St John's Street

This large house is 70 St John's Street, with Mount Pleasant Cottages on the right-hand side. The back of the house faces the viaduct; in the top picture, taken in 2000, the area behind the house has been cleared in preparation for landscaping. In the bottom picture, the landscaping has been attractively completed.

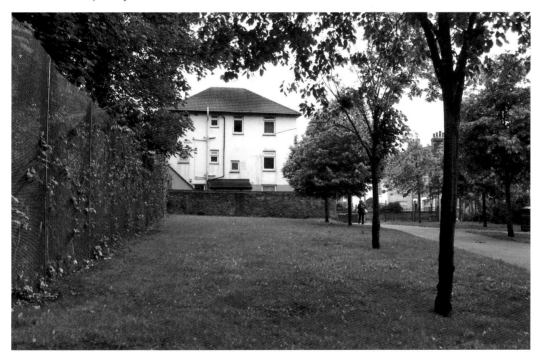

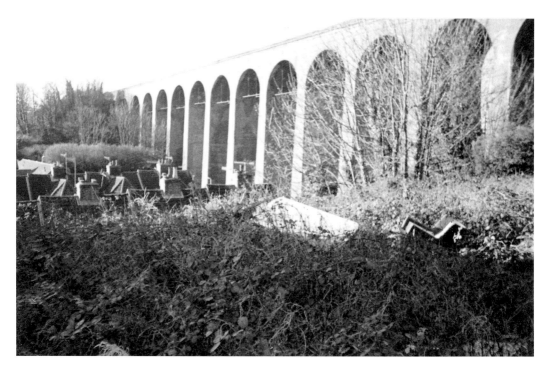

Clearance to the Area above Bradstone Road

The top image shows the area before clearance. It shows the view from Mount Pleasant Cottages. The houses on the left of the picture are the rooftops of houses in Bradstone Road. The bottom image shows the clearance taking place. Note the Network Rail fencing still intact as work is in progress on the Mount Pleasant Cottages side of the viaduct.

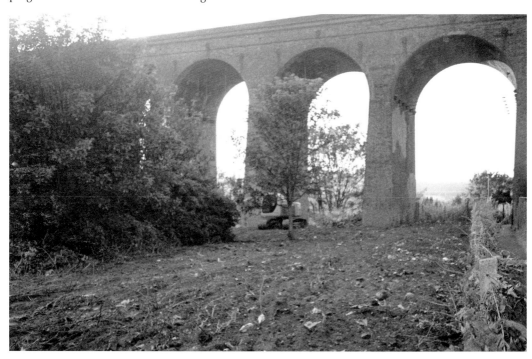

Mount Pleasant Cottages

Above we see Mount Pleasant Cottages with the alleyway leading through to Shepway Close, the Eastfields Estate and onto Blackbull Road. Below we see the front of No. 70 St John's Street. This house must have been an impressive sight situated high on the hillside, with a windmill behind it; alas, the windmill had to be removed as the viaduct hindered the working of the mill.

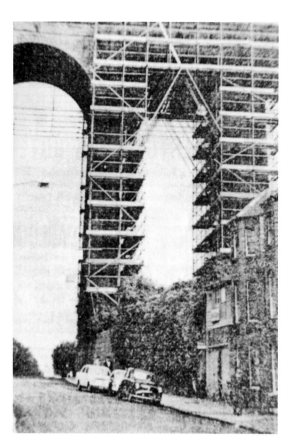

Viaduct Repairs

Repairs to the viaduct on Bradstone Road in 1968. Note the building at the end of the foliage flowing over the wall. The picture below shows the same area with all the foliage removed. Note the space between the wall and the first house; this was where Mr J. Matcham had his plumbing business before relocating to the Vant & Clayson undertakers' building in Cheriton Road.

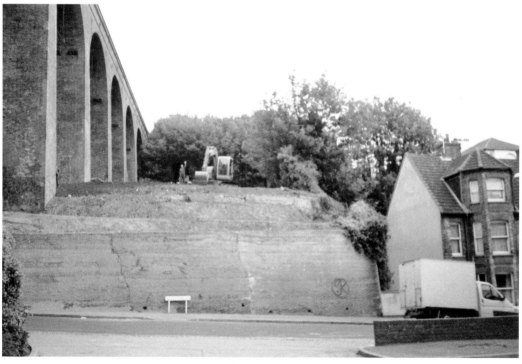

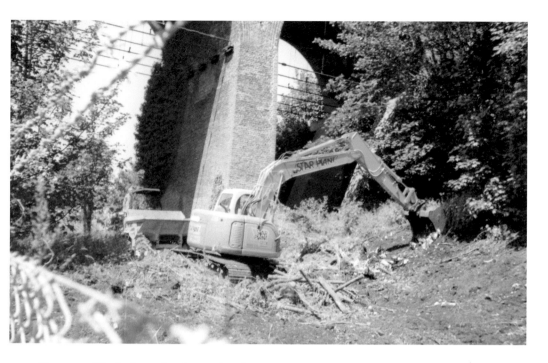

Clearance Work above Bradstone Road

These pictures show the land clearance above Bradstone Road, which exposed a brick wall; this might have been the foundation to John Stace's house. He was a Baptist who owned the Bradstone Mill in the late 1700s and also gave part of his back garden to be a burial ground that still stands in Bradstone Road today, high up on a bank.

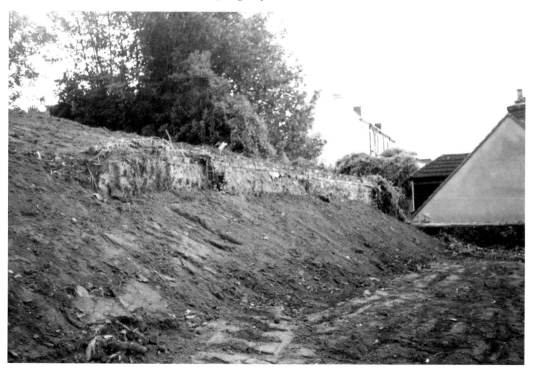

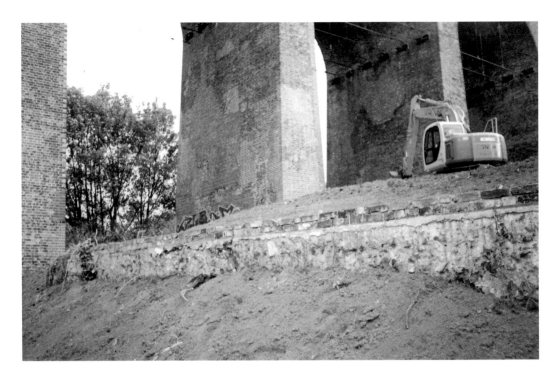

Clearing Shepway Close Side of the Viaduct

In the top picture, the workmen have almost cleared the area above Bradstone Road, exposing more of the viaduct. In the bottom picture, the digger continues down the slope, exposing more walls of a building constructed before the viaduct was even thought of.

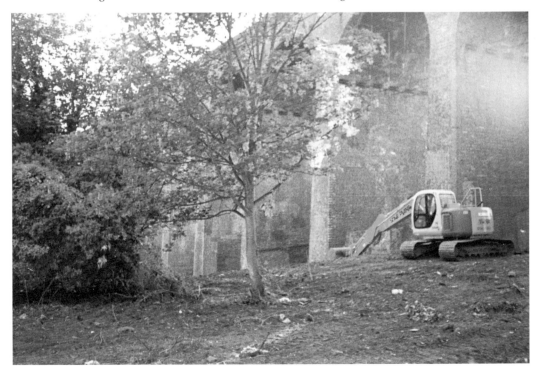

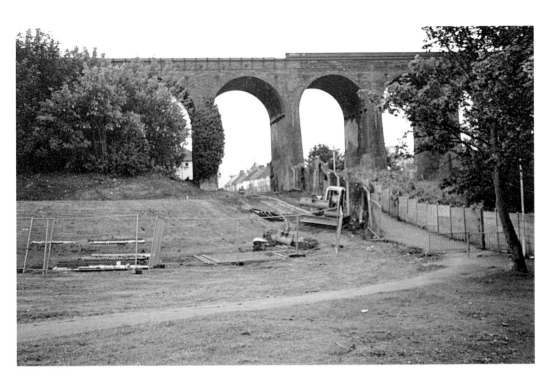

During the Landscaping

The top view is of the Shepway Close side of the viaduct, showing the reclaimed land waiting to be landscaped. The bottom view shows landscaping taking place up to the buildings of the Eastfields Estate.

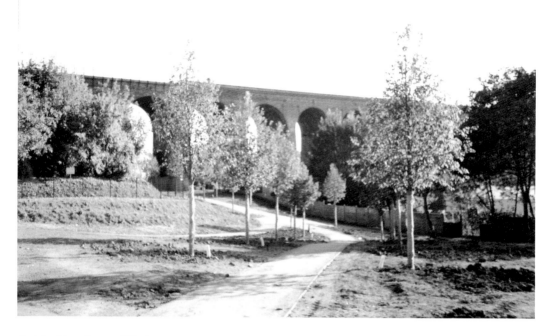

Finished Landscape Work

The landscaping is finished from the viaduct to Eastfields Estate in the photograph above. Below, a year later, the matured look of the now opened-up land is most certainly more pleasing to the eye.

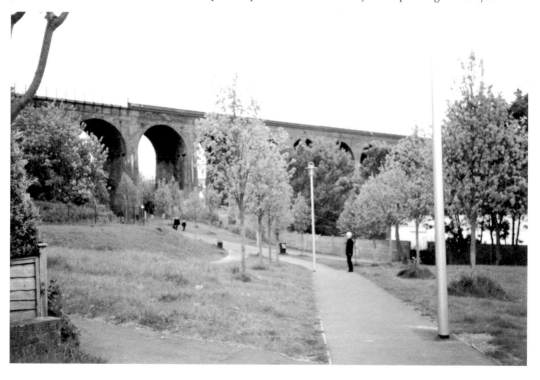

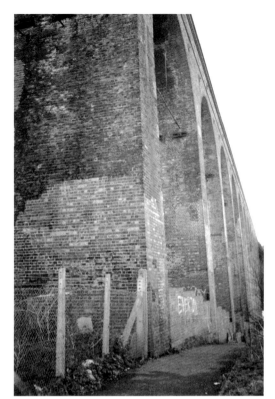

Steps Down to Bradstone Avenue

The above view of the viaduct with the railings down the side shows an alleyway from the Shepway Close side of the viaduct leading down steps that into Bradstone Avenue. The view below shows the scene after refurbishment. Sadly, since this picture was taken, there has been a recurrent problem of graffiti on the viaduct pillars.

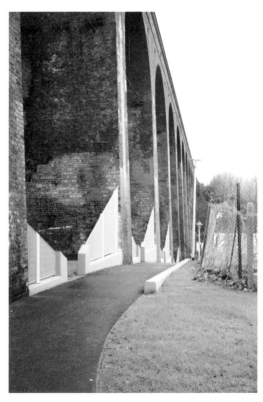

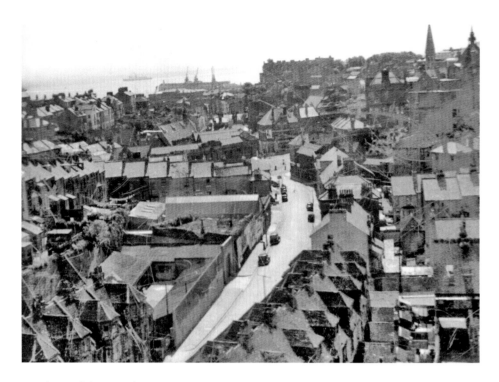

Baptist Burial Ground

The above picture was taken from a train going over the viaduct in 1950, looking down onto the Bradstone Road. Above the first two cars on the left-hand side of the road is the Baptist burial ground. The modern view below was taken from the top of New Street. The burial ground is so overgrown you can only just see two gravestones. In 2010 a working party was organised to clear the ground to make other headstones visible for anyone wishing to view the area where their ancestors were buried. A year later and it is all grown over again.

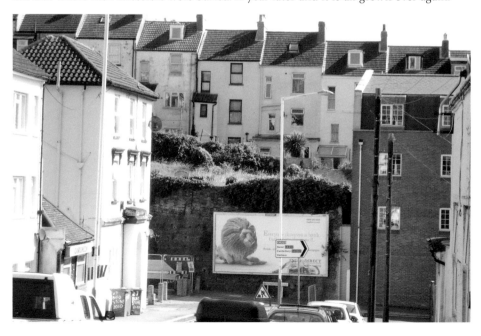

Steps Down to Bradstone Avenue

A workman takes a break from renovating the steps leading down to Bradstone Avenue beside the viaduct to have a chat with the author. He explained what he was doing and said the steps should be a lot safer when he had finished. Sadly, when the steps were completed, for some unknown reason the last set of steps was not replaced, and it was generally felt that this didn't give a finished look to the rest of the refurbished area.

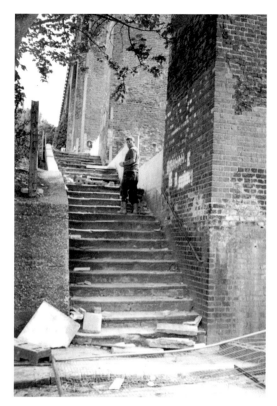

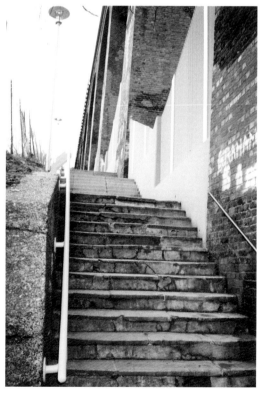

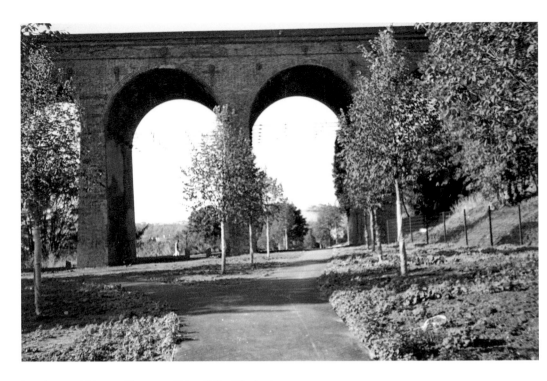

Landscaped Mount Pleasant Side of the Viaduct

Above is the Mount Pleasant Road side of the viaduct as landscaped; note the wire fence to the right of the picture, which is the new boundary of Network Rail property. The picture below, taken from beside the viaduct, is of the Gospel Mission Hall in Foord Road, used as a children's playschool in recent years. Sadly, the building is not currently in use.

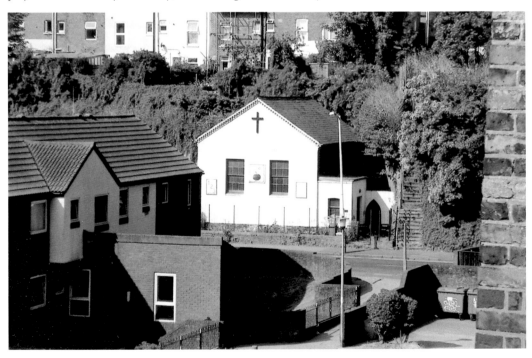

New Shopping Centre on the Horizon

The view above is from the Mount Pleasant Road side of the viaduct; in the distance looms the new shopping centre in Folkestone, opened in November 2007. This was built as part of the refurbishment of Folkestone town centre. Old houses and businesses were demolished to make way for the project. The picture below was taken from the new building, revealing the viaduct still standing proud after more than 160 years.

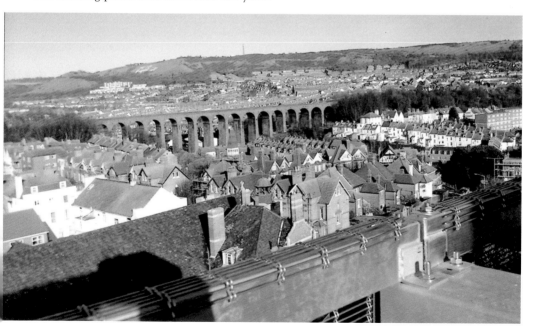

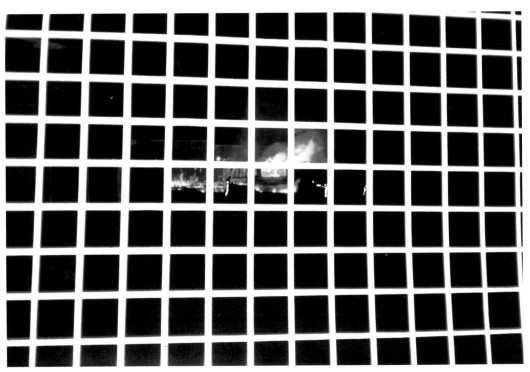

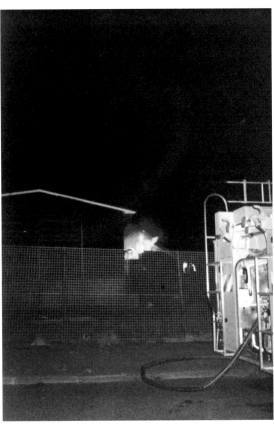

Fire at Key Scheme Centre
In April 2002 a fire broke out at the Dawson Road Key Scheme Centre. The picture above was taken through a fence at around 10.30 p.m. The picture below shows the fire burning forcefully in the background; the building to the left of the photograph is the Dawson Road Youth Club.

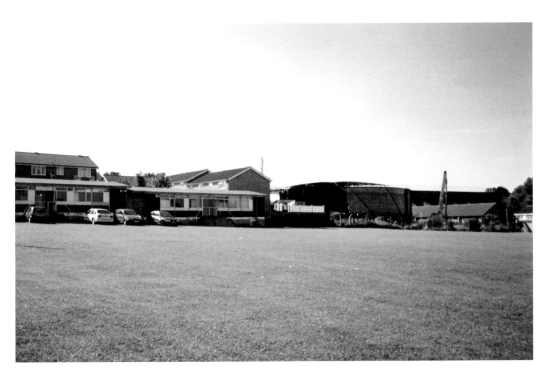

Fire Damage

The photograph above is of the Key Scheme building, Shepway Close, taken before the fire in 2002. The fire damage (below) to the Key Scheme building rendered the building a total write-off and all the equipment inside was damaged beyond repair. It was reported in the local paper that the cause of the fire was arson.

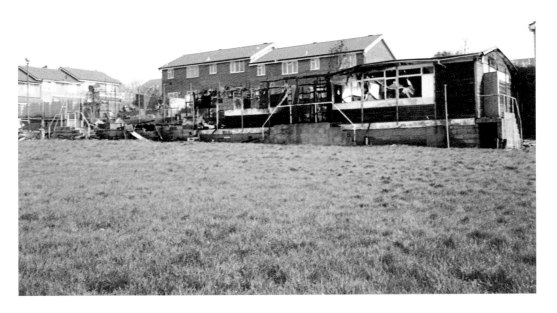

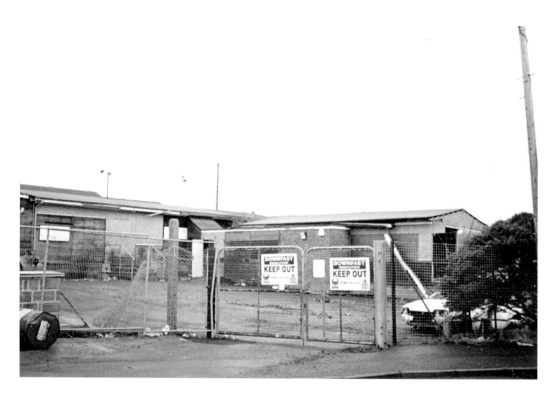

Dawson Road Youth Club

The Dawson Road Youth Club is situated in Shepway Close. The above picture was taken in 2002 before the club was demolished. After the building's demolition in 2003 (below), local residents' worries about its asbestos and the problem of children breaking in and setting fire to the premises were finally resolved.

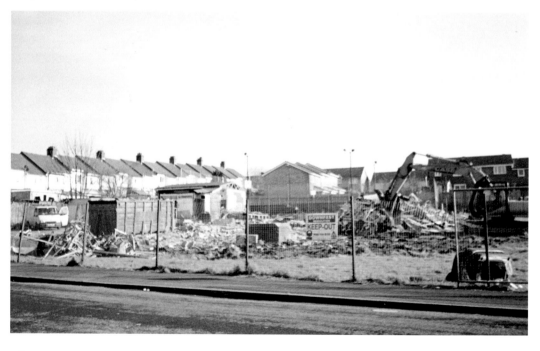

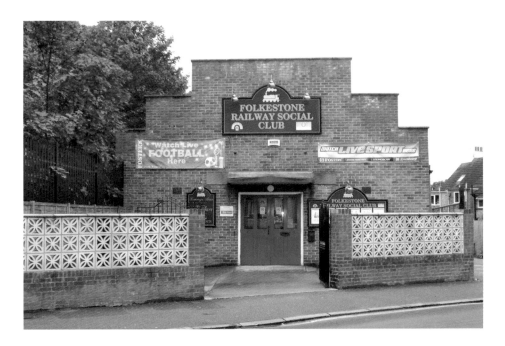

Canterbury Road

Right next to the railway arches (known as the Skew arches) is the Folkestone Railway Social Club; it has held many social functions over the years. Further on was No. 25 Canterbury Road, a house from which Dr Lindsay practised medicine. No. 37 was a wool shop, while No. 39 was a wine store; now, as can be seen in the photograph below, they are a wine and general shop incorporated into one. No. 41 was the Co-op grocery store, then PIC Cheriton (as seen here in 2003) and is now McArdle Pharmacy, which moved across the road from No. 56.

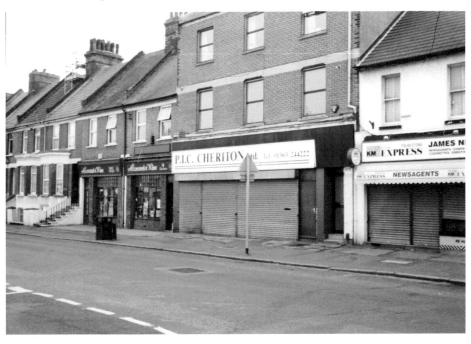

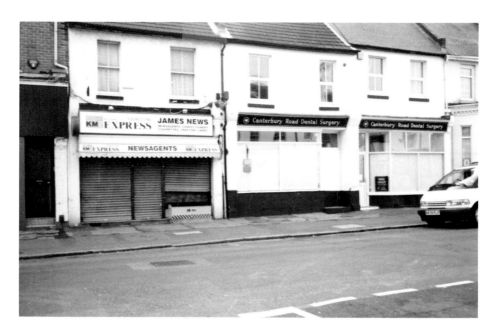

Canterbury Road Shops

No. 43 was a newsagent and grocery shop but is sadly now shut; the next two properties have housed a variety of businesses over the years, one being a shop that sold stuffed toys. Now Nos 45 and 47 are occupied by dentist's. In the picture below, Perfect Partners is at No. 57 and No. 59; it sells glass giftware. In my youth this area belonged to the premises of Frederick George Bricknell, the corn and seed merchant. As a child I used to go with my mother to get the meal to go in the chicken feed, and I can still remember to this day the smell of the place. The site behind the van was where the Congregational church once stood. I am told that a photograph of this building hasn't been found as yet. When the church was pulled down, a block of flats was built to replace it.

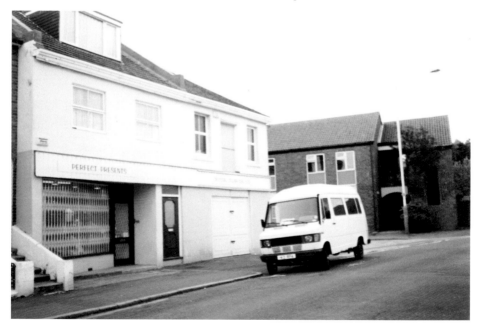

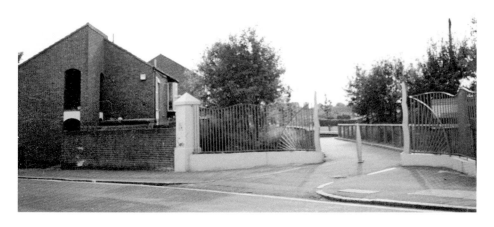

Recreation Ground Entrance

The buildings on the left in the top photograph are part of the flats that replaced the Congregational church. The opening to the right is the entrance to the Canterbury recreation ground, where a big upgrade to the area is to take place: play areas for all ages are planned, with a multi-use games area for the teenagers and play equipment installed for other ages. Next to the recreation ground were the premises of Jesse Sellen, the butcher at No. 67 who I remember wore a straw boater and striped apron. No. 69 was home to Sam Weston, a ladies' hairdresser, and a watchmaker worked at No. 71. These three shops have now been turned into flats, as can be seen in the photograph below. No. 73 belonged to Gordon Poile, the greengrocer. Now it is an Indian takeaway.

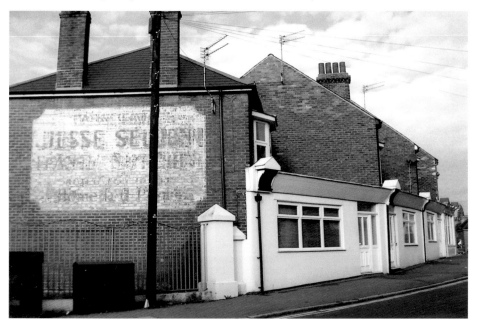

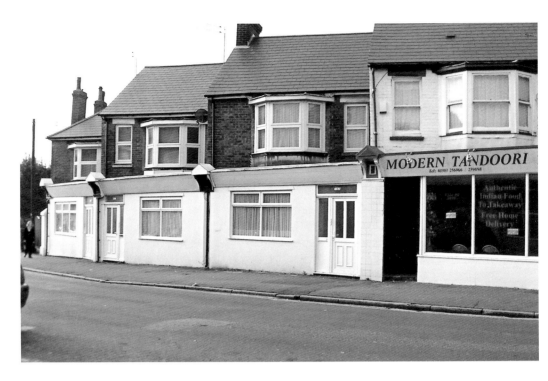

Modern Tandoori

The picture above shows the newly painted Nos 67–71 as flats and No. 73 as an Indian takeaway. Below is the site of the new Salvation Army Citadel that has been built on the old Blue Star Garage site; this is situated on the corner of Canterbury Road and Archer Road. The two houses near to the Archer Road sign were built on the site of a Methodist church.

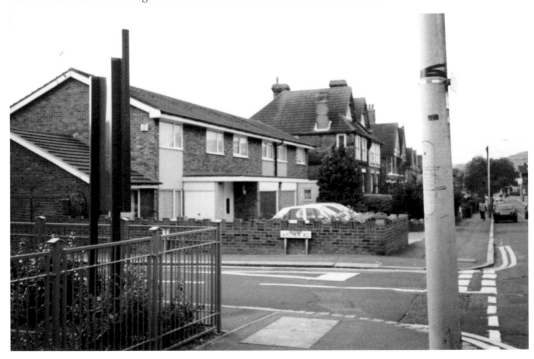

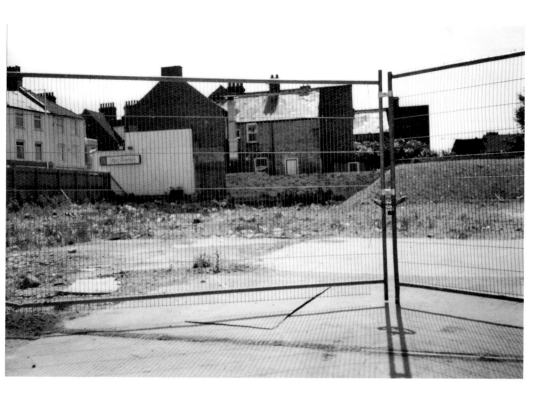

Salvation Army Site

This is the site of the old Blue Star Garage, Nos 75–79 Canterbury Road, in June 2001. The placard below was put on the hoarding around the old Blue Star Garage site at this time. We all wondered how long it would be until the new church was built; much to our amazement, by July 2002 we were invited to an open day.

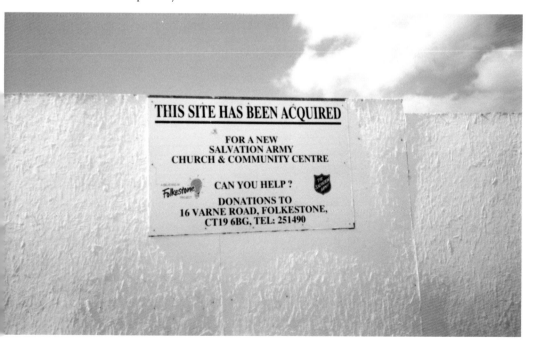

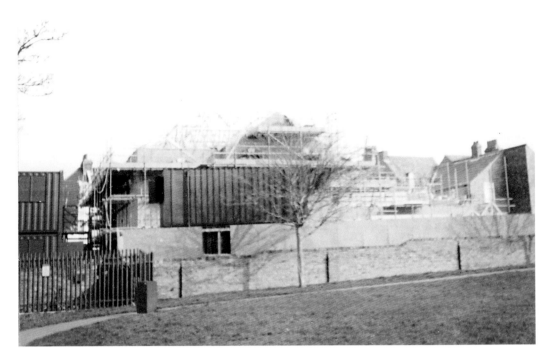

Building Works

The Salvation Army Citadel is under construction in the image above. A workman took the photograph below from the top level of scaffolding, revealing the recreation ground and the viaduct in the distance. This area was once brickfields which were used to supply the builders of the viaduct.

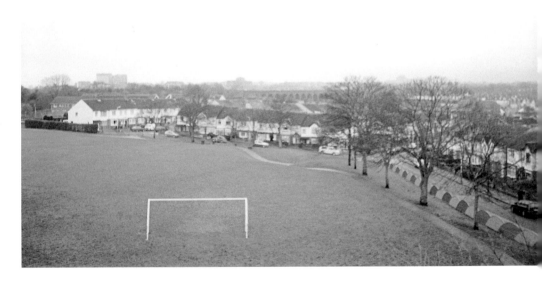

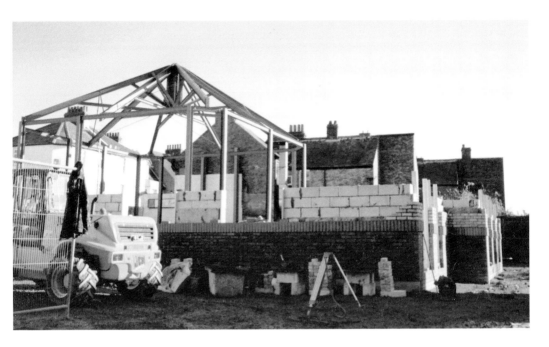

Salvation Army Citadel
The new Salvation Army Citadel is taking shape in the image above and has been completed in the image below. The front of the building is situated at the top of Archer Road and the side of the building runs alongside the Canterbury Road recreation ground.

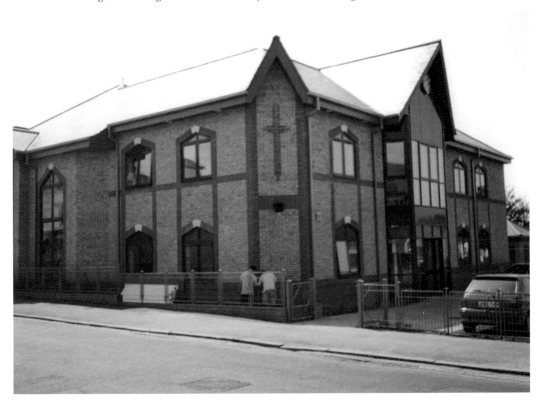

Inside the Building

In the entrance hallway I was greeted by a Salvation Army officer. Visiting the building for the first time, he kindly offered to show me around the building. Below is one of the small halls used for various activities.

Finishing Touches

A workman is shown carrying out the finishing touches to the doorway of another room in the Salvation Army Citadel. The large, modern kitchen (below) was used to prepare many meals and cups of tea for people who were removed from their homes during the earthquake of 2007. Today the kitchen is used to prepare meals for pensioners at lunchtime on Thursdays. The Salvation Army also have a playschool for pre-school children; at different times of the year the SA hold a craft fair and sell old jigsaw puzzles and other unwanted items to help raise funds for when an emergency arises.

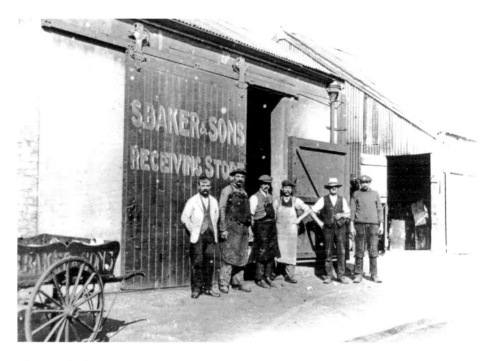

Ginger Baker's

At the bottom of Green Lane was the place known in the area as Ginger Baker's, the rag-and-bone man. In my early childhood I used to take old rags and glass bottles here to get some pocket money. The old picture was taken at the turn of the twentieth century is of Samuel Baker's premises, i.e. Ginger Baker's. The modern photograph shows the two blocks of flats at the bottom of Green Lane. Half of the lower block of flats that was No. 94 and No. 95 Canterbury Road used to be Creteway petrol station.

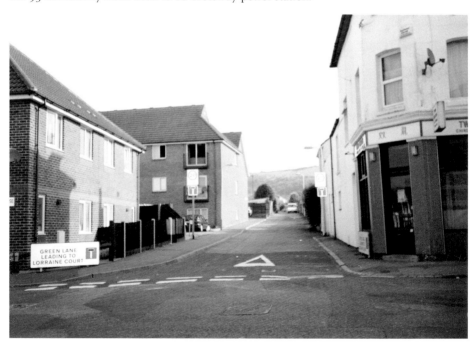

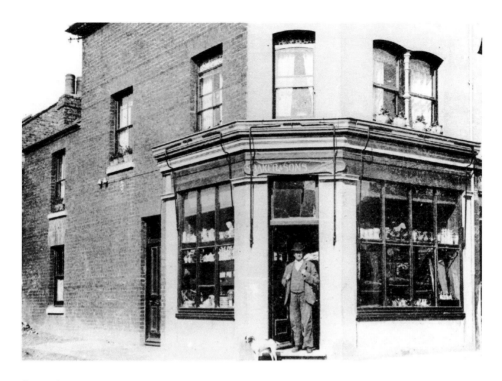

Green Lane

Taken in 1891, the top photograph shows a property at the bottom of Green Lane, but it is actually No. 80 Canterbury Road. This has always been used as a shop; in 1891 Samuel Baker owned it and sold all sorts of second-hand goods. The shop has been a greengrocer and is today a Chinese takeaway, which can be seen on the far left in the photograph below. Nos 74–78 are now flats, but about twenty years ago No. 78 was a bakery that sold bread and cakes. No. 76 was Marina's hair salon, run by a Mrs Titley. No. 74, on the corner of Sidney Street, was Jones the boot repairer's.

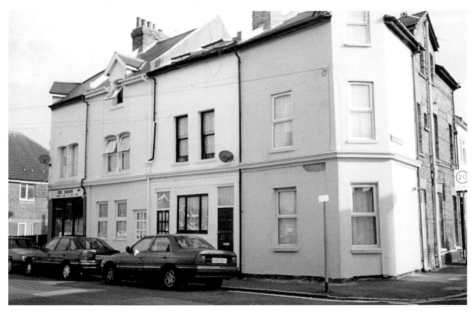

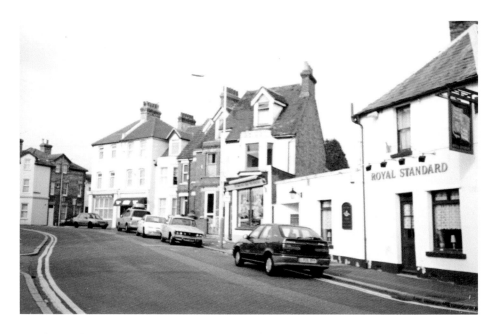

Royal Standard Public House

Continuing along Canterbury Road, Jones the boot repairer's shop can be seen on the corner of Sidney Street in the top photograph. The next shop is No. 72, which was also for many years was a boot repairer's and is now a hairdresser's; No. 70 next door has been a newsagent for as long as I can remember. The next shop is No. 62; it has always been known as Marsh's fish and chip shop, but over the years it has also been an estate agent and has now reverted back to being a fish and chip shop again. No. 60 is the Royal Standard public house. Across the road from the Royal Standard at No. 58 was the Two Bells, as shown in the photograph below, which is now shut and lies empty. No. 56 was for many years the premises of Bill Devereese, the boot repairer, then it became McArdle Pharmacy until the business moved across the road to what was the old Co-op site of No. 41 Canterbury Road. Then it became a craft shop and is now a private residence.

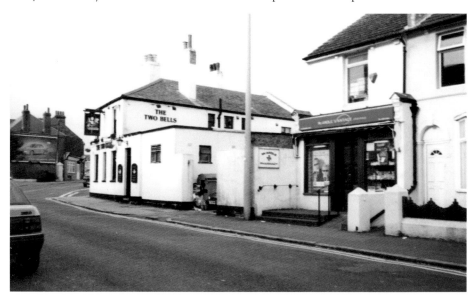

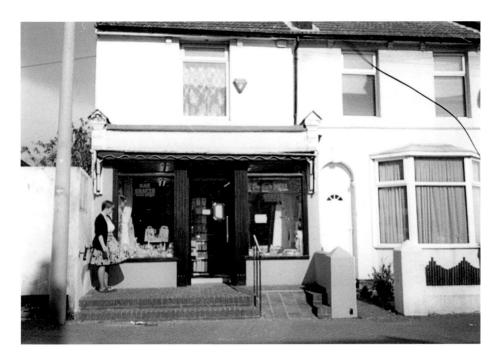

Craft Shop

Above is the craft shop at No. 56. After being empty for a few years, it is now a private dwelling. At the far left of the picture below is No. 56 while No. 50 Canterbury Road is on the corner of Denmark Street; this has been a greengrocer's and sweetshop and now is a doctors' surgery. The next shop is No. 48; this has been an electrical supplier and fishing tackle shop and is today a florist, although when pictured in 2005 it was occupied by business offering financial services. No. 46 was once Dr Lindsay's surgery.

Florist

The florist at No. 48 has made the road more colourful with the bright array of flowers on display. No. 38, now a dwelling, has been the premises of both a grocer and a wine seller. No. 30, on the corner of Canterbury Road and Princess Street has been a grocer's shop, and a sweetshop but is now a private dwelling.

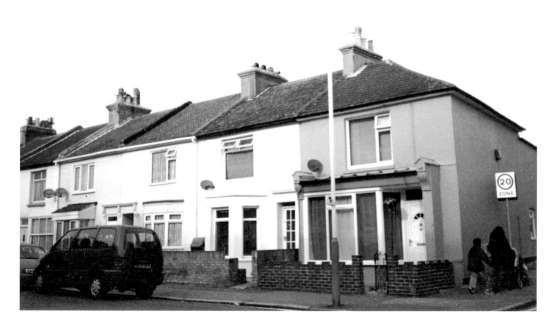

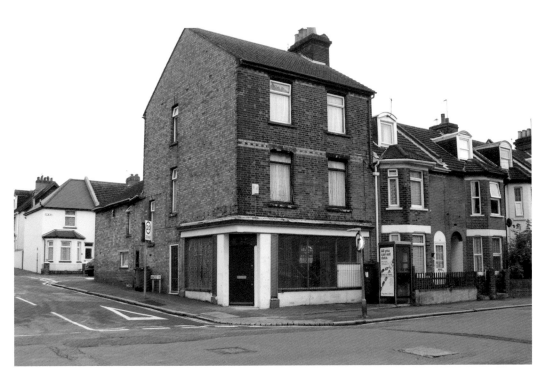

Old Post Office, Canterbury Road

No. 26 (above) was the post office for as many years as I can remember, then it became a second-hand shop but now has shut down. Nos 2–6, shown below as a dwelling, was once Slades the furniture shop and has sold a wide variety of second-hand goods over the years. This concludes our tour of the Canterbury Road area.

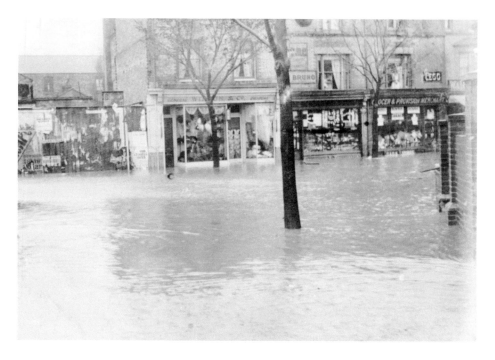

Floods of 1909 in Blackbull Road

We start at No. 5 Blackbull Road, a draper's. The picture above was taken in 1909 when the area was flooded. No. 7 and No. 9 were general grocer's shops. The recent picture of the same properties shows that No. 5 has been converted into flats but once was the Co-op. No. 7 had been the premises of a tobacconist, then a hairdresser, and is now a café. No. 9 has become a Chinese takeaway.

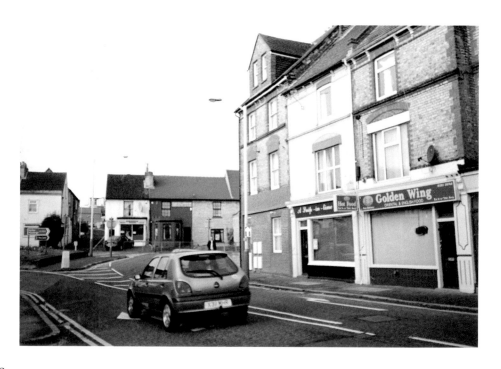

Preston's Dairy Shop

No. 23, the building on the left of the top picture, was once J. A. Preston's dairy shop, selling produce from Park Farm. The sign on the side wall is a reminder of this. The property has also been electrical engineer's shop and Fosters Imperial Steam Laundry Co. Ltd, but is now a private residence. Across the Pavillion Road that leads into Blackbull Road, on the corner, is No. 25, now a locksmith's. In the past the property has been a furniture shop, a gift shop and a motorcycle shop. The next property, No. 29, is Mario's fish and chip shop, which was a chip shop even before the war. No. 31 was a greengrocer's and even though it has changed hands over the years it remained a greengrocer's; sadly today it is shut and Mario next door uses it as a store. Nos 33–35 are the location of the Imperial public house and hotel.

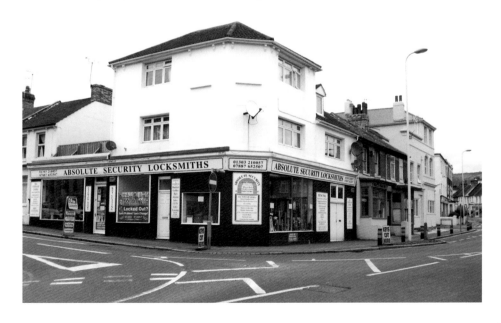

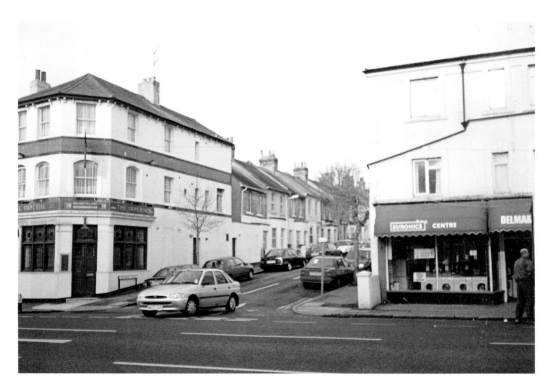

Imperial Public House

The Imperial public house, pictured above in 2006, was on the corner of Blackbull Road and Jesmond Street. Nos 37–39 were the location of Delmaines, which sold washing machines and fridges. In 2011, as pictured below, the Imperial has been converted into flats.

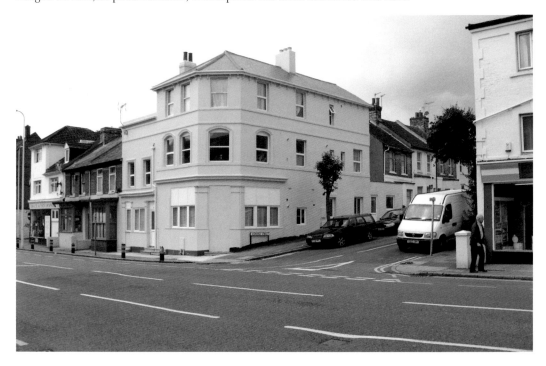

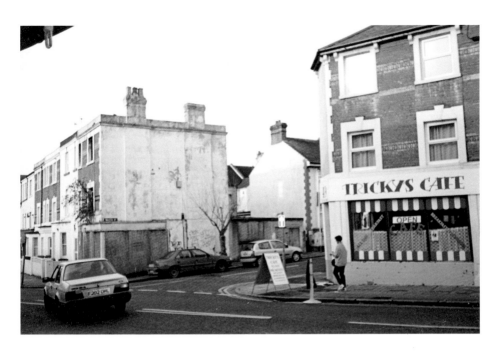

Trickys Café

On the corner of Walton Road and Blackbull Road were two buildings, Nos 45 and 47. No. 47 was a grocer's, then a sweetshop. Now Nos 45 and 47 have been pulled down, as they were deemed structurally unsafe. Since the demolition of the buildings, the area often has rubbish dumped on it. Local residents have asked when the land will be developed, but as yet nothing has happened to remove the eyesore. No. 49 is shown above in 2006 as Trickys Café. It was once Leslie's the grocer and many times as a child I went to buy broken biscuits there. Today it is the Blackbull Café, as pictured below. The next two shops, Nos 51 and 53 were for many years Wells & Son, a butcher's shop, but has now become a nail bar and tattooist's. No. 55 was Hoile's newsagent's and No. 57 was a launderette.

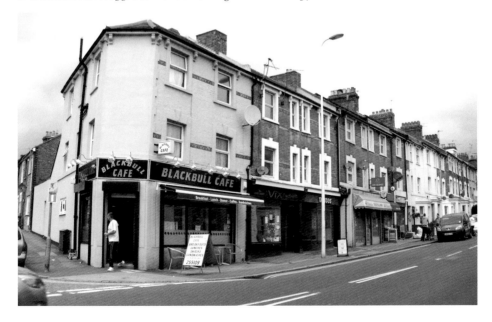

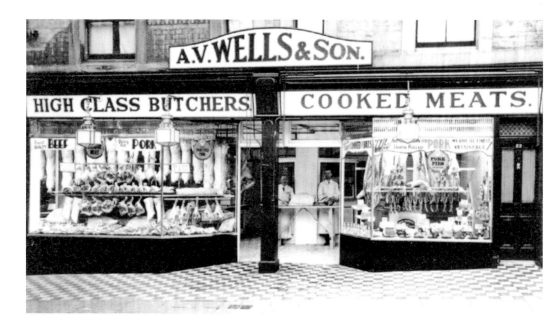

Butcher's Long Ago

The picture above, of Wells & Son's butcher's shop, Nos 51 and 53 Blackbull Road, was taken around 1925. In the picture below, the black-painted shopfronts show the location where Wells & Son were based. Nos 55 and 57 are a combined newsagent and grocery shop.

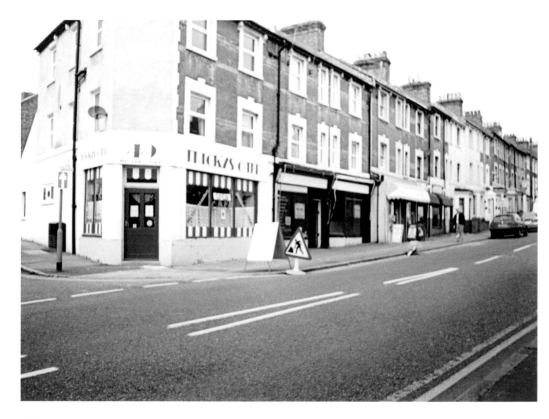

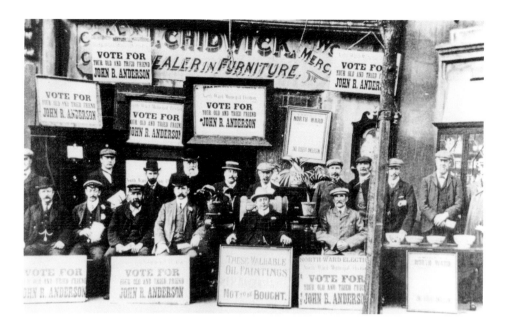

Floods of 1996

The old picture is of No. 57 Blackbull Road and was taken in the early 1900s. It shows the premises of J. Chidwick, a furniture dealer. Below is the scene in Blackbull Road, looking down the road from Walton Road, during the floods of 12 August 1996. The picture was taken at midday on the day of the floods, as the rain had stopped and the water was subsiding. Earlier, looking down Blackbull Road, you could see the water was above the top of the shop doorways; it was hard to imagine the volume of water needed to fill up that area. When I returned at 4 p.m. to see what was happening, there was not a drop of water – just a bit of sludge, and many damaged houses.

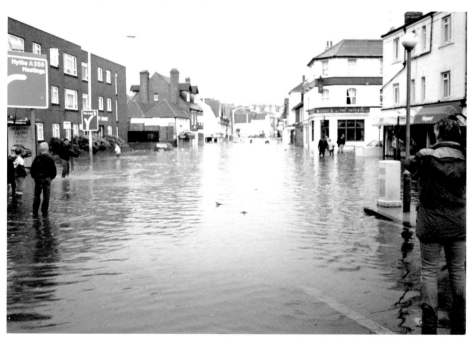

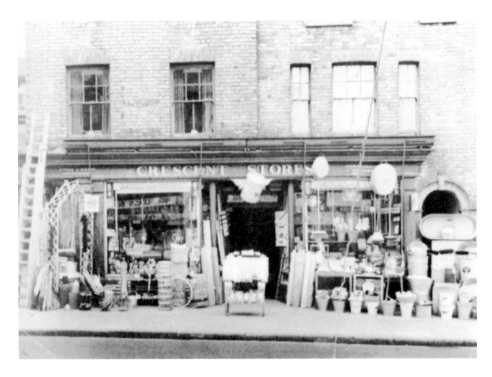

Crescent Stores

Nos 32 and 34 Blackbull Road, pictured in the 1950s, were the site of Crescent Stores, a hardware shop. My mother would say they sold everything from a pin to an elephant. On the opposite side of Blackbull Road, the shop on the far left of the colour photograph, No. 36, was a wool and haberdashery shop; now it is a Chinese takeaway. No. 26 is Tizzy's the hairdresser's – at one time a confectioner's and before that a butcher's.

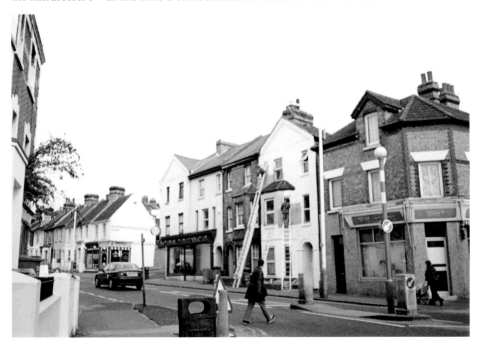

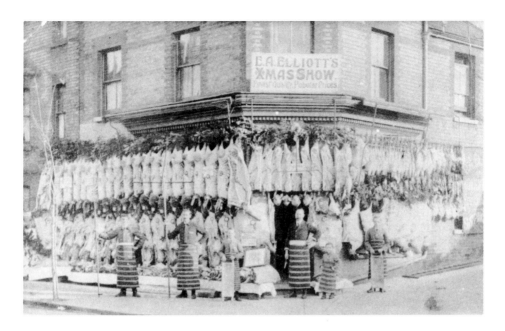

Tizzy's the Hairdresser's

This early picture of No. 26 Blackbull Road is of E. A. Elliott's butcher's shop. What a sight to see so much meat and poultry hanging outside the shop – all that meat outside would no doubt give today's health and safety officers nightmares. In the modern photograph No. 26 is now home to Tizzy's hairdresser's; note the word 'Butchers' over the entrance – at the time the photograph was taken the shop was undergoing a repaint which exposed the old writing. At the side of Tizzy's are steps up to Shepway Close.

George Peden Memorial
By the steps up to Shepway Close, a strangely built wall contains part of a memorial stone to George Peden, a much-loved councillor who died in 1905. A fountain was dedicated to him in 1909 and erected in Blackbull Road, in appreciation of the great work he did for the people of the Foord area, but when sewer works took place the memorial was taken away and never put back. Now what is left of the memorial stone has been covered by foliage.

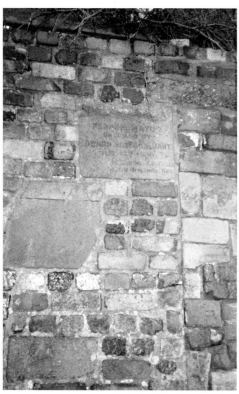

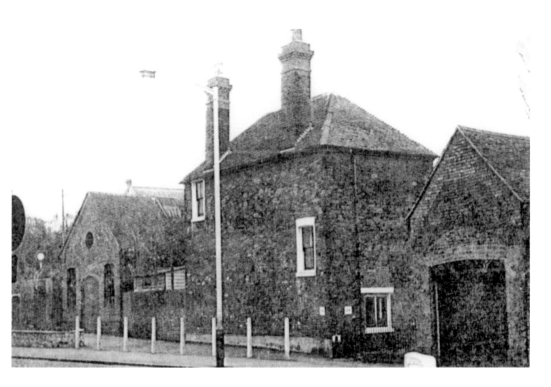

Gas Pumping Station

In the picture above, the old building to the left of the house was a gas pumping station. The house, No. 24, is seen from the back. As a child walking past I would think what a strange house it was, with no visible door and few windows; only years later did I realise the front of the house faced the viaduct. The workshop next door was an old blacksmith's forge in the 1880s, worked by a Charles Dray, a distant ancestor of my husband. These buildings were pulled down the 1960s to make way for the building of the block of flats called Cubitt House, pictured below.

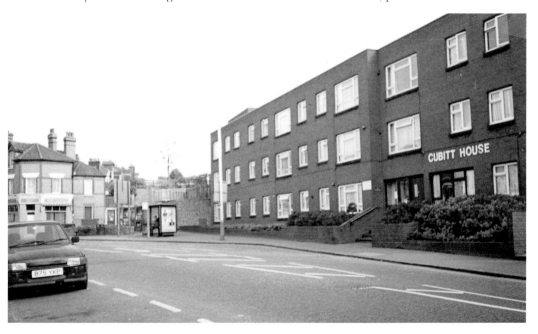

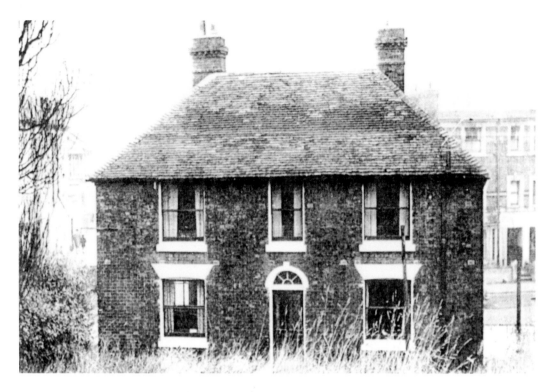

Mystery House

This house is No. 24 Blackbull Road and faced the viaduct; the back of the house faced the main road. As yet I haven't managed to find out why it was built this way round. In the image below, the horse trough, erected in 1912, is being used by the carters to water their horses; it would have stood outside the entrance to what is now Cubitt House, remaining there until a bus stop area was built along with Cubitt House.

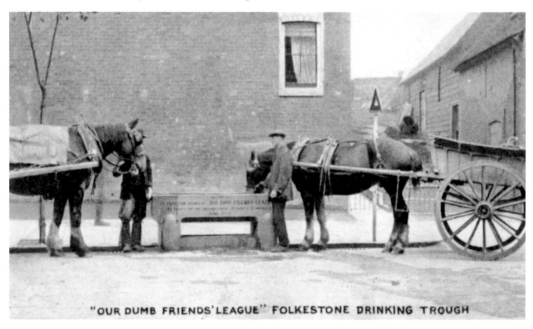

"OUR DUMB FRIENDS' LEAGUE" FOLKESTONE DRINKING TROUGH

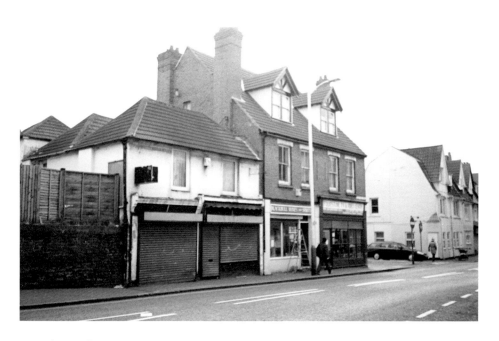

One Shop Left

In the above image, the two shops that have the shutters down are Nos 22a and 22b. No. 22a was Symes the barber, while No. 22b was Downs the confectioner; these two shops were unbelievably small. At the time this picture was taken in 2003, No. 20 was an off-licence and No. 20a a television repair shop. The off-licence was once a tobacconist, and the television shop was once a butcher's. Apart from the television shop, the others in this block have been converted to dwellings. Crossing over Bradstone Road, we come to No. 12, which was Gibbs the newsagent's; the shop was a Chinese takeaway until it was made into flats around 2000. No. 10 had been a baker's, No. 8 a watchmaker's, No. 6 a greengrocer's shop, No. 4 sold wet fish, and No. 2 was the premises of an electrical engineer. All these properties have slowly over the years been turned into dwellings.

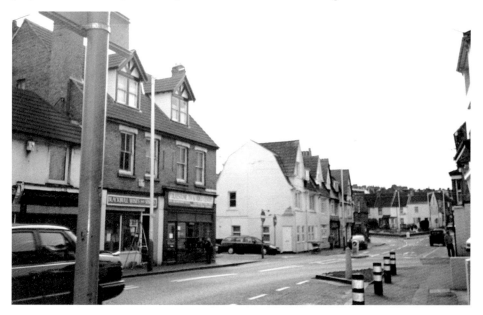

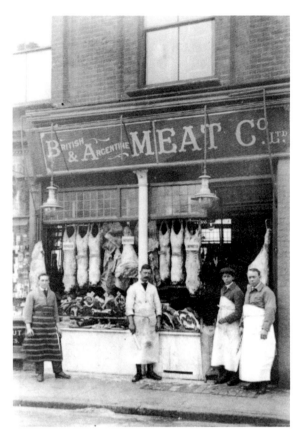

Look What I've Got in My Back Yard!
No. 20a was the British & Argentine
Meat Company, which operated under
this name before the war. When I
was a child, it was called Carden's the
butcher's. In the modern photograph
you can see the newly built houses in
Bradstone Avenue, which were built
in the back garden of the television
shop. I really don't know how it was
allowed as it was a very tight squeeze.
As yet these dwellings have no house
numbers on them, but as they follow
on from No. 54 Bradstone Avenue,
maybe they are Nos 56 and 58.

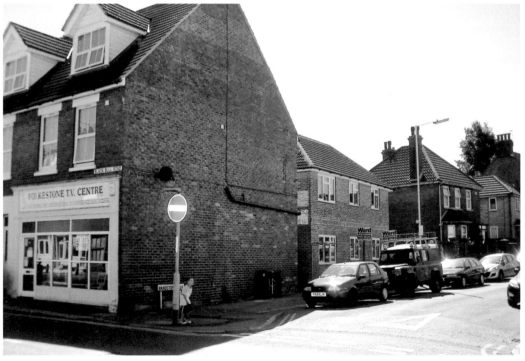

Here Today, Gone Tomorrow

The house standing with its flank wall showing in the top picture is No. 45 Bradstone Avenue. The empty space was once home to a car repair workshop owned by Derek Bailey. He was well known for sidecar racing and one-time world champion, but his career ended after a crash at the Isle of Man races. In the photograph below, there are now three houses occupying the old car repair site: Nos 47, 48 and 49. Nos 53–57 were the premises of a small second-hand car showroom named Hatchback.

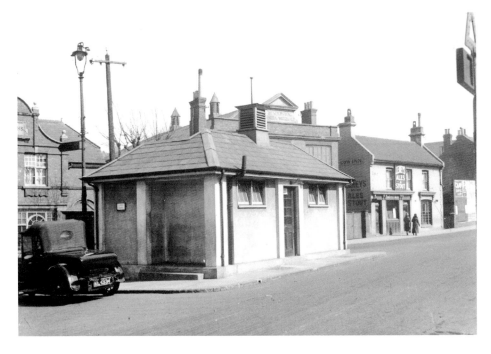

Foco Club

Starting at the end of Blackbull Road and entering Foord Road, we have the Foco Club at No. 144. This building at one time housed the public baths. Even though my grandmother had a bathroom fitted by the 1960s, she said she still liked to go down to have her bath there. A friend of mine also had to go there as she had no bathroom, but she found the experience quite frightening; as it was so noisy. By the late 1960s most people had bathrooms and the building had become redundant. In the middle of the old photograph, taken in 1929, is a public toilet that was demolished when the road was widened.

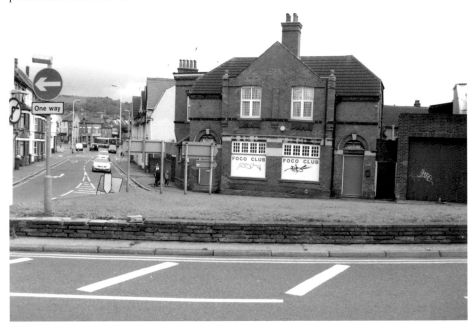

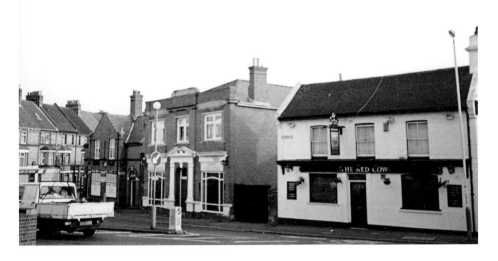

Red Cow Public House

Next to No. 144 was No. 140, where the Silver Spring factory made soft drinks until the company expanded and moved the business to Park Farm Road. The site is now occupied by an upholstery company. Nos 134–138 are the premises of the Red Cow public house, which is said to have opened in 1682 and is reputed to be Folkestone's oldest surviving public house that is still housed in its original building (with possible the exception of the British Lion), which can be found behind the later Victorian façade. Nos 130–132 were home to Unique Engineering, and No. 132 was also the office of Tunbridge Wells Equitable Friendly Society. No. 126 was the local cobbler's; Herbert Errington owned and worked the business. No. 120 was a newsagent and sweetshop, while No. 122 was Folkestone Radio Relays Ltd. A picture-framing business was run from No. 122; it is now an accountant's office.

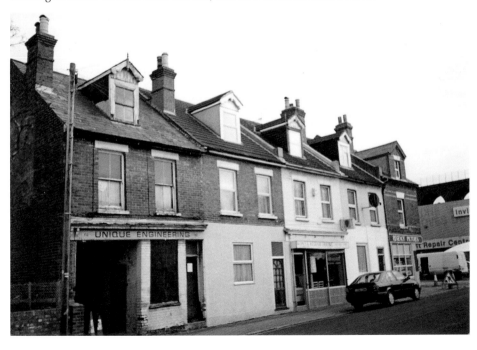

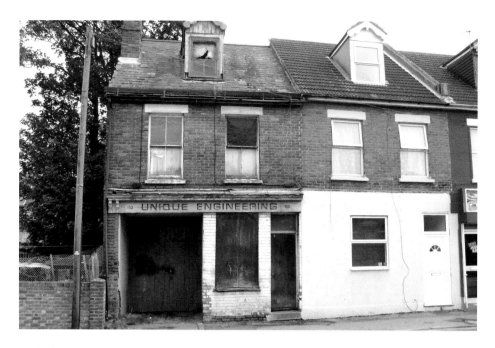

A Hidden View Rarely Seen

The photograph above shows the front of Unique Engineering, and what was hidden over the years behind this façade surprised me. A friend of mine informed me that in the late 1950s there was hall through the door on the left where he and several other chaps went to do boxing training. As this area has been uninhabited for many years, there was no chance of me being able to see the hall, but about three years ago I noticed workmen in the yard behind the Unique frontage. I rattled the gates and they let me in and said they were demolishing the building in the yard and that when this was finished a cottage and some garages were to be built the next year, but nothing seems to have happened. The picture below shows the yard area during the demolition.

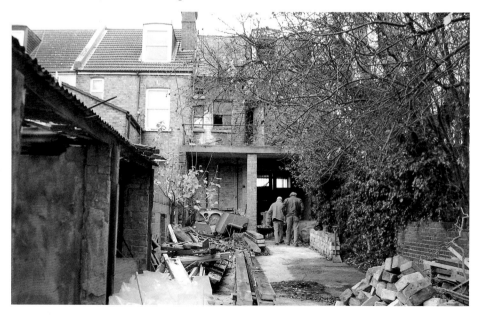

Old Gas House

The shop on the left of this 1910 photograph would have been Errington's boot repairer's shop. The large building to the right of the picture is the Gas House. The modern photograph shows Nos 130–122. The only businesses now are the kebab shop at 126 and the accountant's offices at 122. After the side road, which is Sussex Road, there used to be eleven buildings: seven private dwellings and four businesses. What would have been No. 120 were the premises of Mrs Clark, a druggist. No. 104 was Peacock's motor engineer's. No. 96 was home to Lummus, the cycle dealer's, while on the corner of Foord Road and Devon Road was Leslie's Café. On this site now is a storage company and a Tesco Express.

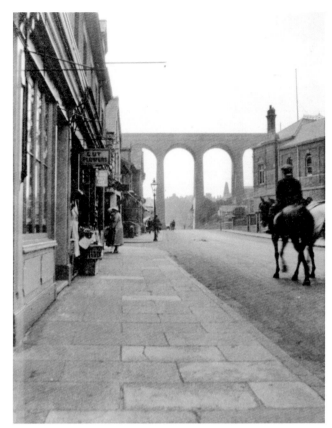

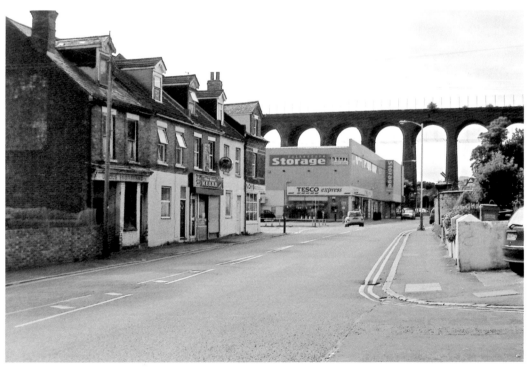

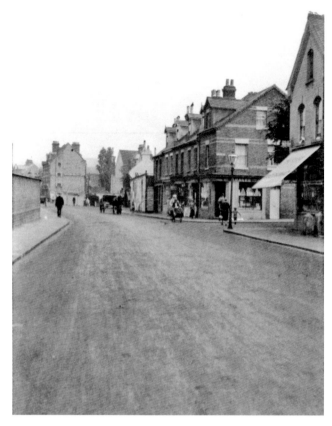

Mrs Clark's Druggist Shop

The old photograph, taken in 1910, shows Foord road, looking towards Blackbull Road, with the viaduct behind the photographer. The shop on the right-hand side with the awning down was Mrs Clark's druggist shop, as it was called then, at No. 120. No. 122 at this time was a baker's, while a newsagent's was located at No. 126. The same view in 2011 shows the Tesco store taking up Nos 104–94. No. 122 is Nicki's Accountancy Services, on the corner of Foord Road and Sussex Road.

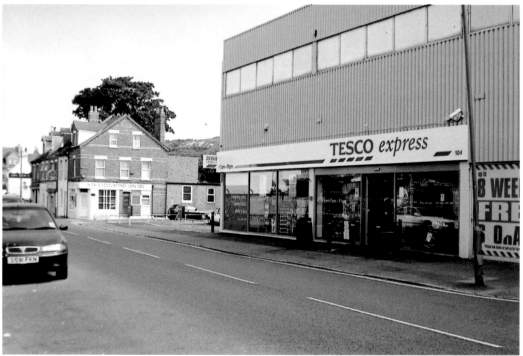

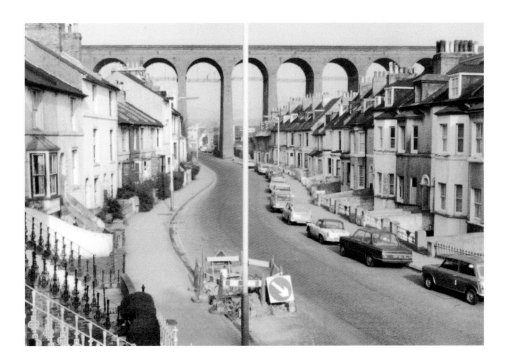

Old Foord Road

The top photograph is from the 1980s and shows the other side of the viaduct, just before both sides of the road were demolished. The Corporation had a yard where today's Barratt car showroom is situated, and the numbers from there start at No. 80 on the right-hand side of the photograph. Apart from No. 38 being an off-licence and No. 30 being the *Daily News* publisher, there were no other shops on either side of the road. The picture below shows the scene after the demolition of both sides of Foord Road has taken place.

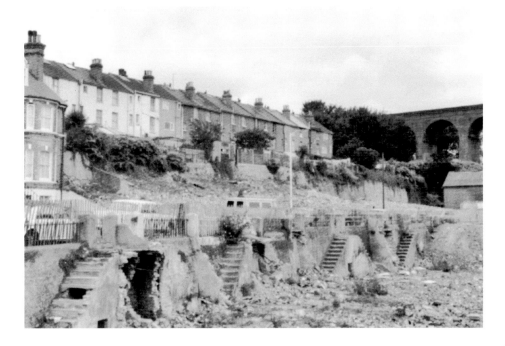

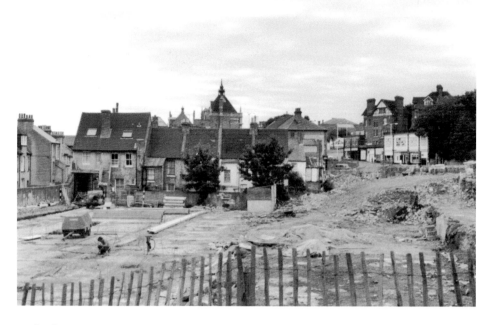

Back of New Street

The picture above depicts the demolition of the left-hand side of Foord Road and was taken with the photographer's back to the viaduct; the houses facing the demolished site are the backs of the houses situated in New Street. The colour picture was taken from the beginning of Grace Hill and shows the flats built on either side of the road. The flats on the left of the picture were named Bradford Court and Albert Costain Court, while the flats on the right-hand side were named Stephen Court and opened in 1983. The white building in the distance is the Gospel Mission Hall and has been left untouched.

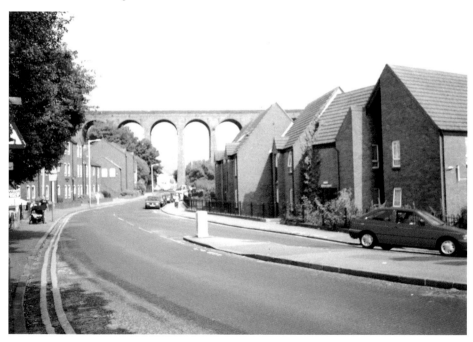

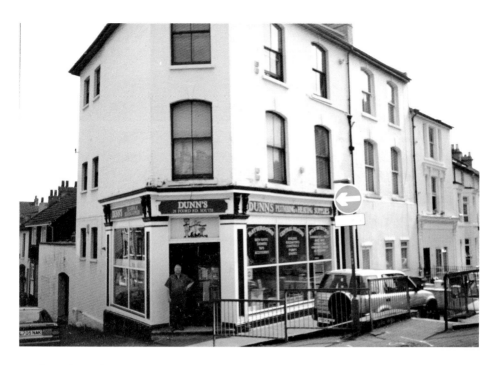

Ford Road South

The last building in this sequence on this side of the road is No. 120, Dunn's plumbing firm, with Mr Dunn standing in the doorway in the above picture. Sadly, the building has been converted into flats. The road from Dunn's (below) was a continuation of Foord Road, but today it is called Foord Road South; this road continues down to Dover Road and at one time there were eight businesses trading along here, including a motorcycle dealer, a furniture supplier, Ball's sign writers, a wholesaler of fruit and vegetables, a maker of rubber balloons, a watchmaker, a hairdresser and a fish restaurant. This area now has been converted into flats.

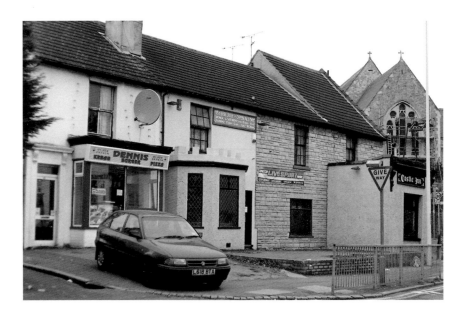

St John's Church

Now we go to the Blackbull Road end of Foord Road and start with the Castle Inn at No. 77. This inn was built in 1818, and apparently operated as a beer house from 1838 to 1864. It was named the Castle Inn after the mock ruin sited opposite, which enclosed the Chalybeate spring. This feature would attract people to the area for the spring water it was hoped, but unfortunately it did not and was abandoned. Nos 75 and 73 are now incorporated into the Castle Inn for accommodation, and No. 71 is a kebab shop; it was a fish and chip shop before that. At the side of the kebab shop was a building that looked as if it was attached to the shop, but according to local street directory, it appears to be No. 1 Palmerstone Street, a very grim-looking cottage that had been empty many years.

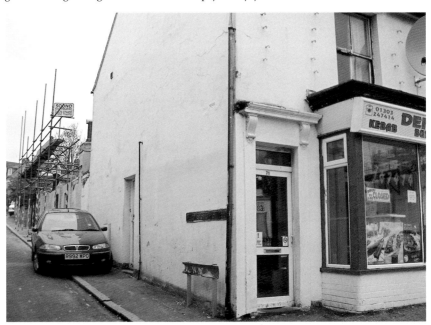

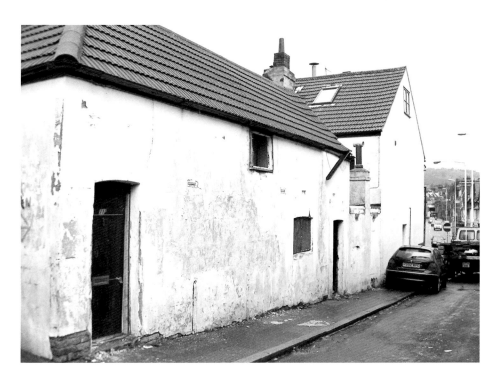

No. 1 Palmerstone Street

The picture above shows the cottage at the back of the kebab shop at No. 71 Foord Road before the former property was demolished. Below we see the site after demolition took place in 2009. On viewing the area, I feel it would be better for the kebab shop to have this area as a garden instead of trying to get three houses built on the site, which is what was planned.

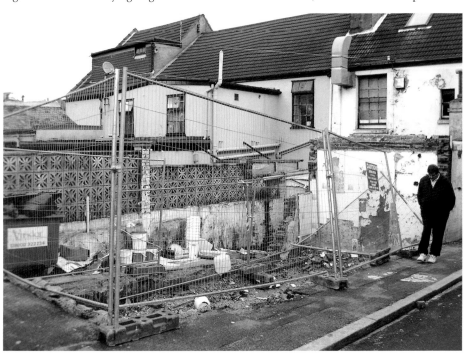

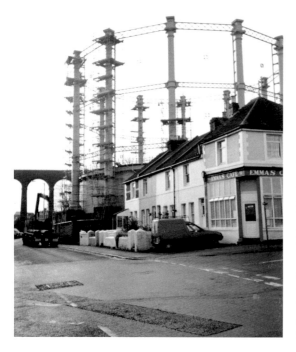

Emma's Café

At No. 55 is Emma's Café and on the skyline in the picture to the left one can see the remains of the demolition of the gas holder with the viaduct behind it. Emma's Café has had many names, but was always known as a workman's café. Sadly, it has recently shut its doors. Over Palmerstone Road, on the opposite corner, was Cloak's furniture dealer's at No. 69 and next to it was A. J. Kemp, turf commission agent. From No. 69 down to No. 53 are now all dwellings.

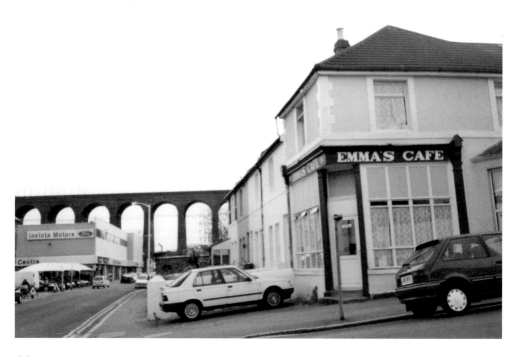

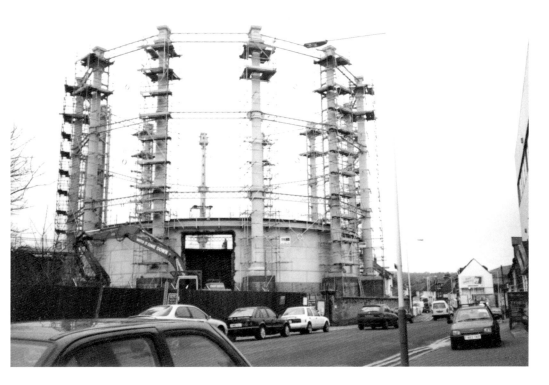

Gas Holder

Above is the largest of the gas holders situated in Foord Road, during the demolition process in 2001. With the largest gas holder now gone, we find exposed a beautiful Victorian wall (below). I just couldn't resist taking a photograph of it for posterity. I asked one of the workmen on the site to pose for me to show people the enormity of the old Victorian wall in case when the site is developed it disappears overnight, so to speak.

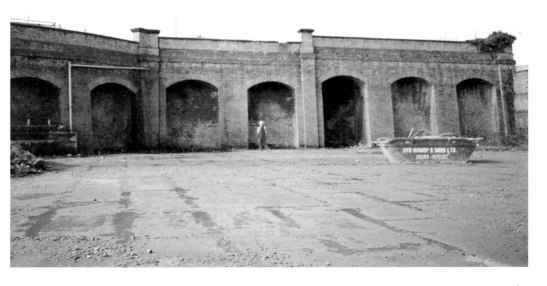

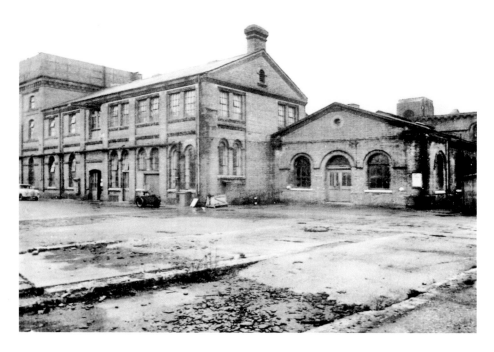

Old Gas Works Building

The above photograph depicts the old buildings on the gas works site and was taken possibly in the late 1950s. Where the trees are on the left of the picture below was where the buildings in the picture above would have been situated. The doors visible behind the locked gates belonged to the Gas Club. It was a sad day for its members when it was demolished. An auction took place in September 2000 to sell off 125 items. A treasured billiards table, valued at around £10,000, sold for just £750 – just months after the club had spent £600 on a new cloth for it. It was said that at the sale many members left before the end, with tears in their eyes at the sad loss of their club.

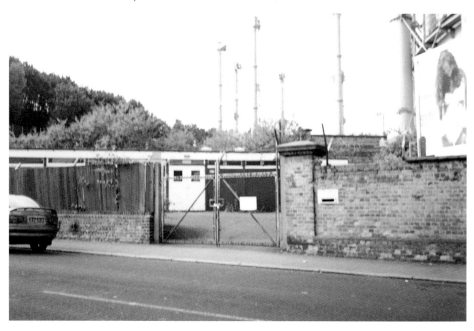

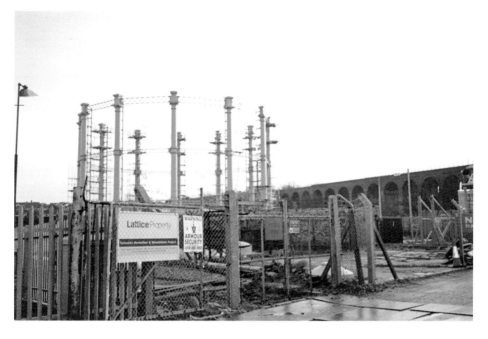

Gas Works Site

The gas holder above was a small one situated in the Ship Street gas works area and was also demolished at the same time as the other two. The picture below, an aerial view of the gas works area in about 1950, was donated by friend. The large gas holder in the distance was the one that was situated on what is now the Peto Close development.

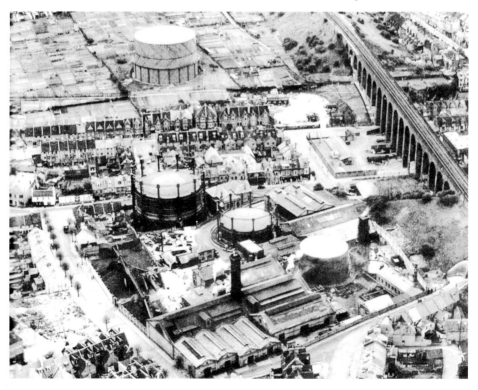

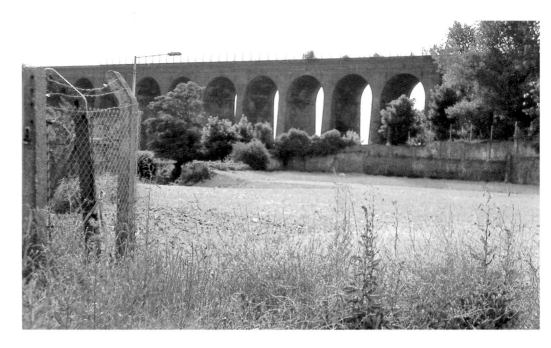

Gas Works Site After Demolition

The Ship Street gas works site area is now cleared and decontaminated. Against the wall in the background of the top picture once stood some of the villa residences that are shown in the 1881 and 1891 Ordinance Survey maps. These slowly disappeared as the gas works needed more room; the properties were therefore bought and demolished. The houses in the background of the picture below are part of Broadmead Road from Darlington Arch to the central station. The exposed, strange-looking brick wall was once part of the work sheds for the gas company. The cleared land is to the right of the picture above.

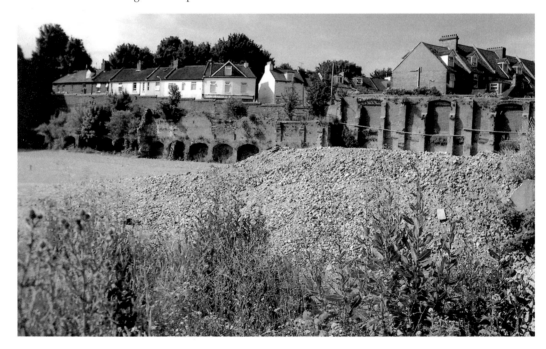

Ship Street

The blue-roofed building in the distance of the picture above is the Air Cadet hut. Also on the right, the building on the corner of Ship Street and Boscombe Road is No. 1 Boscombe Road. From about the 1940s to the 1960s a Mr Vivian Record lived there; he was a friend of my father who told me he was a brilliant engineer but he felt sorry for his wife because he had engines and parts scattered all over the house. On the corner of Bournemouth Road and Ship Street is No. 2 Bournemouth Road, which was for many years a baker's and has also been a veterinary surgery. Walking from Bournemouth Road into Broadmead Road, the shops on the right are the shops that can be seen in the bottom photograph on the previous page. These were all shops in the 1970s and before. The following businesses used to operate here: Taylor Austen, builder (No. 1); Pemble Electrical Engineers (No. 1b); a fruiterer's (No. 3); George Loulli's fish and chip shop (No. 5); Richard Leigh, hairdresser (No. 7); Sidney Fisher, boot repairer (No. 9), an electrical repair shop (No. 15) and a tobacconist (No. 17). Today, the buildings are now dwellings.

Darlington Arch

The photograph above shows the Darlington Arch from Guildhall Street in 2000. On the left of the picture are Nos 91–93; the whole building is J. A. Hitchcock & Son, motorcycle engineers, mainly dealing in Triumph motorcycles. On 28 June 1843, the railway reached Folkestone. The first train stopped at the small temporary station in the fields near the Darlington Arch. The picture below shows the same scene in 2011. Note how overgrown the area has become. Hitchcock's business has shut but his son still lives above the shop. On the left, between the shop and the houses, was the site of the Eagle public house, formerly the Darlington Arms, built in 1855 and demolished in 1950.

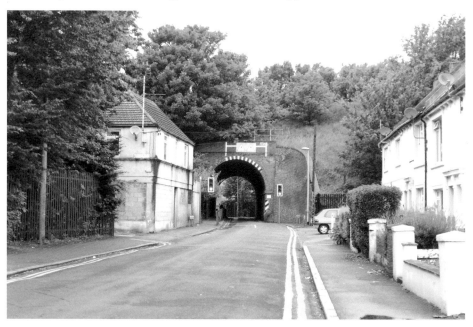

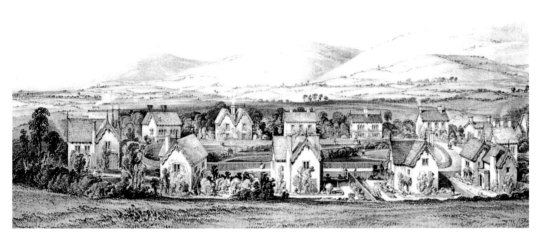

Viaduct Villas

Above is an artist's depiction of the grand-looking villas that were built between Ship Street and the viaduct; they only remained a few years as the gas works needed more land. Below are Ordnance Survey maps of 1881 and 1898, which show where the villas were situated. According to census records and local street directories, the villas were all gone by 1905.

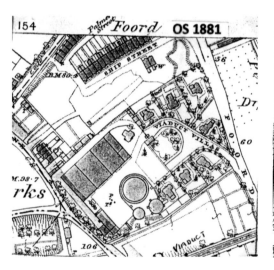
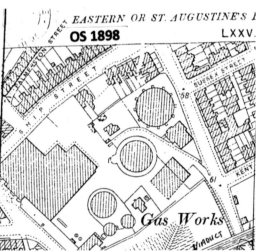

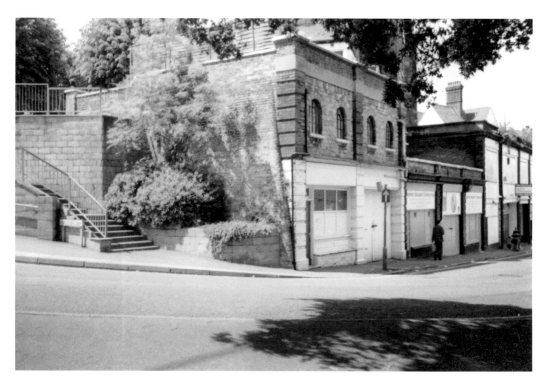

Steps up to Copthall Gardens
Grace Hill continues where Foord Road ends to the right of this picture. Over time this area has been home to many businesses. To the left, opposite the steps in the picture above, are the steps that lead down to Foord Road South, once called the Bull Dog steps.

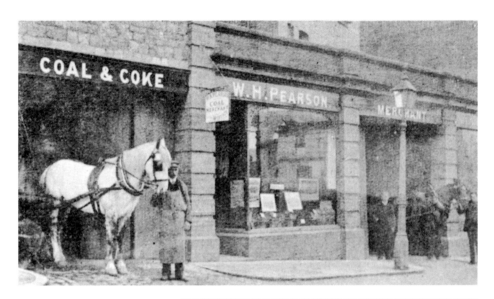

Pictures of Grace Hill, 1890s
The above picture was taken in the 1890s; it shows Nos 31–35. If you look at the picture at the top of the next page, you will see that Nos 31–35 would be in the middle of the buildings.
The other picture here also dates from the last decade of the nineteenth century and shows another Grace Hill shop, possibly No. 29.

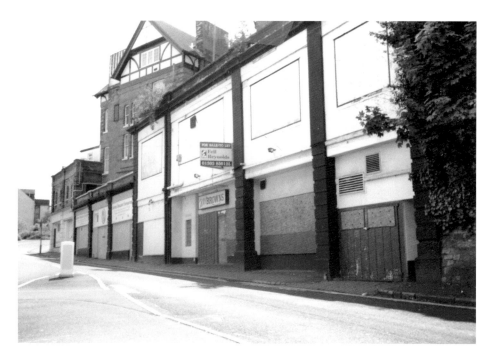

Grace Hill and William Harvey Grammar School

The long shot of Grace Hill in 2004 shows the units unoccupied apart from the yellow-coloured building in which Shepway Building Contractors have their premises. The other units have since been redeveloped. Below is the magnificent building that was the old Harvey Grammar School, which lies at the end of Foord Road and the beginning of Grace Hill. A trust set up by William Harvey, the eminent physician, funded the building of the school, which later moved to larger premises. For many years the structure served the community as a dental and maternity clinic, but it has now been turned into flats.

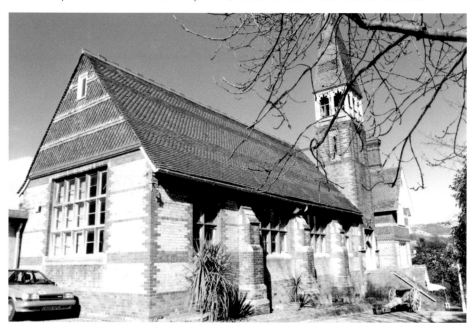

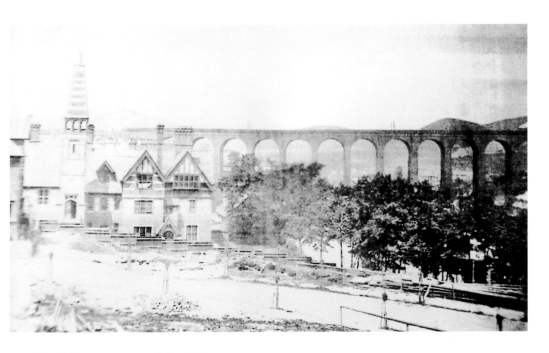

Road Improvements of the 1880s

The old photograph was taken in the late 1880s when Folkestone was developing. The steeple on the left belongs to the Harvey Grammar School, and of course there is the faithful Foord viaduct standing proud. The modern picture was taken from the same place and is of the roundabout at the bottom of Foresters Way, which was formerly Shellons Street. The large tree on the roundabout is reputed to be the tree that was in the garden of the Foresters public house that was situated near the Copthall Garden steps. This roundabout splits Grace Hill, which then continues towards Rendezvous Street.

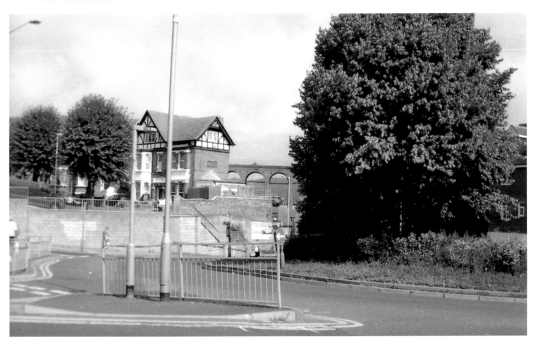

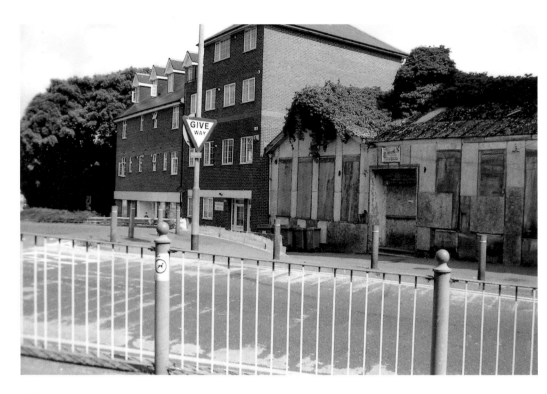

Grace Chapel

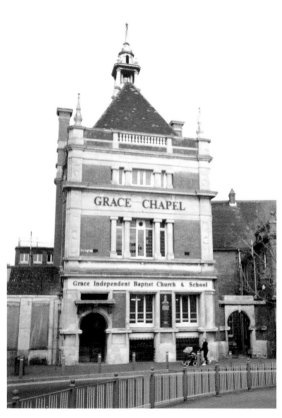

The photograph above shows Grace Hill on the side of the steps that lead down to Foord Road South. Before the two blocks of flats were built, there were two shops here: a ladies' hairdresser named Boucelette at No. 20 and a gents' barber's, Arthur Cook, at No. 18. No. 16 was Partington's Kent Poster Advertising Company, while the next building, which is overgrown with foliage and boarded up, was once the Harvey Grammar School canteen annex. The picture opposite shows Grace Chapel, an independent church school. On 23 October 1895, Stephen Penfold, the mayor of Folkestone, laid the foundation stone. Inside, the building is a spacious and light place with a sweeping staircase to a lower floor. The chapel is still in use today for various functions.

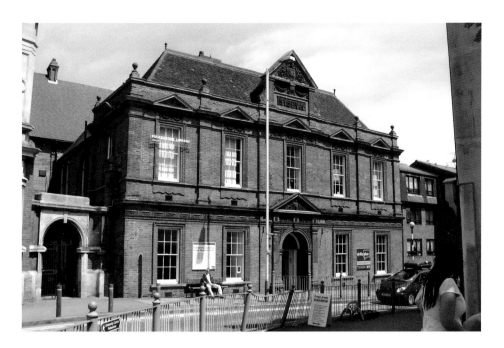

Public Library

Next to Grace Chapel is the public library (above), which was built in 1887. And next to the library was the Methodist church that was pulled down for flats built on the site. The photograph below, taken in 2000, shows the shops opposite the library as one looks down towards Rendezvous Street. Renhams Cycle Centre is at No. 17, a second-hand furniture dealer is at No. 15, No. 13 is empty, No. 11 is the location of Temple Barton estate agent's, and the Masonic Hall is at No. 9. In the far distance, a large amusements sign marks the joining of Dover Road and Rendezvous Street. Going up Rendezvous Street, past the amusements sign, is a boarded-off piece of land that would soon to be built on.

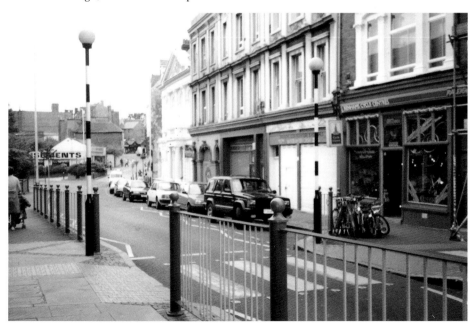

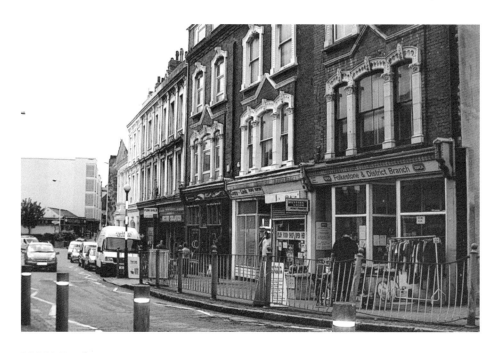

RSPCA Headquarters

The top picture, taken in 2011, shows the changes from the picture taken in 2000 of the Grace Hill area. No. 21 Grace Hill is now the RSPCA headquarters. No. 19 is a shared between a Polish food shop and a printing shop. No. 17 is still home to Renhams Cycle Centre. A second-hand furniture dealer still operates from No. 15. A fancy-dress hire shop is based at No. 13, while No. 11 is up for sale. The Masonic Hall is still at No. 9. In the background, a large block of flats has been built. The bottom picture is the view from Rendezvous Street looking towards No. 21 Grace Hill.

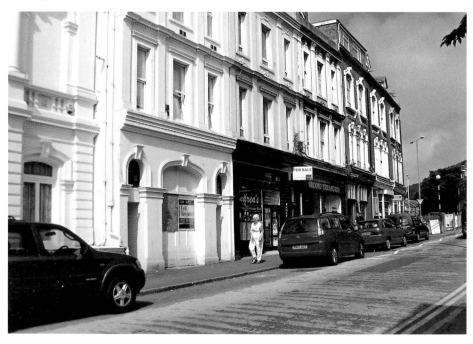

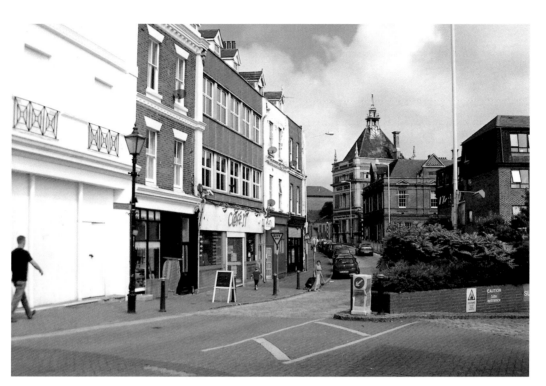

Masonic Hall

On the right-hand side of the top
picture are the flats built on the
Methodist church site, then the
public library and Grace Chapel.
On the left-hand side, the first
white-painted building, No. 1, was
the Savoy Cinema; it was a bingo
hall called the Metronome after
the cinema closed. No. 3 was a
picture-framing shop, but is now
a second-hand dealer. No. 5 was
a meat importer's premises and
is now an IT café. No. 7 is a taxi
office. The grand-looking building
shown in full in the other
photograph is the Masonic Hall at
No. 9 Grace Hill. The foundation
stone was laid by R.W. Bro. Earl
Amherst, Provincial Grand Master
of Kent, on 7 July 1886.

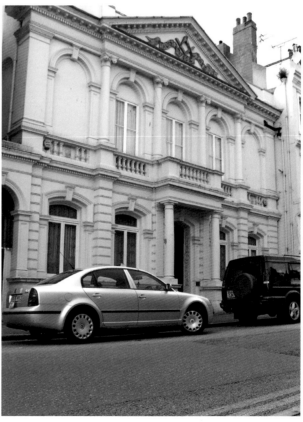

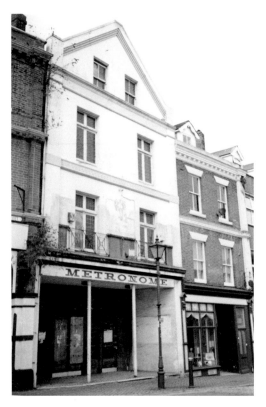

Metronome
The Metronome, No. 1 Grace Hill, is shown
in 1999 after the bingo hall closed. Today it
is boarded up and repainted, and there is
talk of it becoming an indoor market, but as
yet no planning permission has been sought.

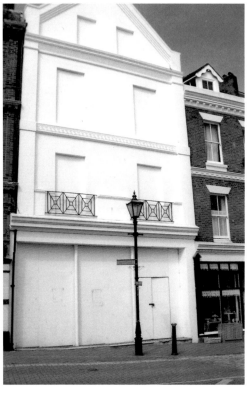

New Flats in Rendezvous Street

The above picture was taken in the spring of 2008 from the steps of the old Baptist church, which is now the Samuel Peto public house. Workmen were at this time surveying the area for redevelopment. Williams the electrical dealer is to be demolished to make way for flats and an expansion of the amusement arcade. The picture below was taken from the same spot in 2010; the flats are built as planned and the amusements run underneath the building. People have remarked that having the bars outside the windows does not give much of an outlook. The problem was that directly opposite there is a block of flats called Merchant Place and the residents here have balconies and do not wish to be overlooked from across the road.

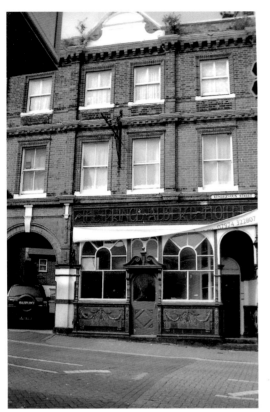

Prince Albert Public House

No. 29 Rendezvous Street is the Prince Albert public house, which was thought to have opened in 1841. In 1987 it closed and in 1989 opened as Berties, which sadly closed in 1990. Wiltshire's cycle shop was next door; this was a large shop and when it was pulled down there was a very large space vacant, so for a few years an open air market was held there. Over the course of time people complained it was an eyesore. The Merchant Place flats were then built on the site. The picture below, taken in 2003, shows the old Baptist church, which had contained small workshops and a sort of indoor market, but was converted into a Wetherspoons pub. The sign on the architrave has more recently been changed to 'The Samuel Peto', after the engineer involved in the building of the viaduct.

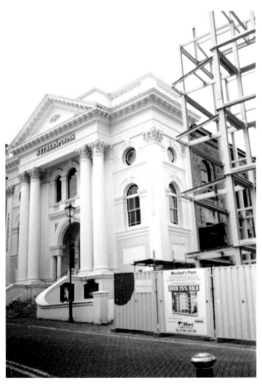

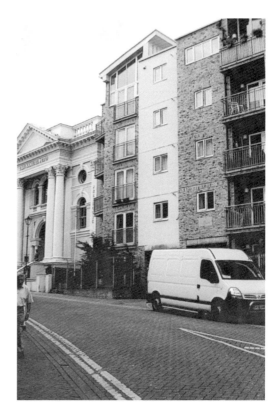

Once a Baptist Church
The Merchant Place flats to the right of the Samuel Peto were built on the site where Wiltshire's cycle shop once stood. The Samuel Peto occupies the old Baptist church, whose dedication stone was laid on 7 August 1873 by William Sampson, the pastor.

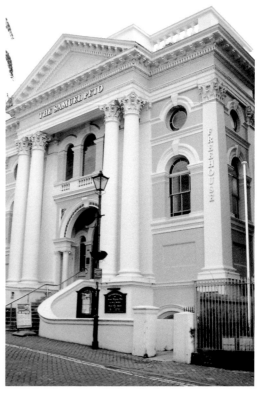

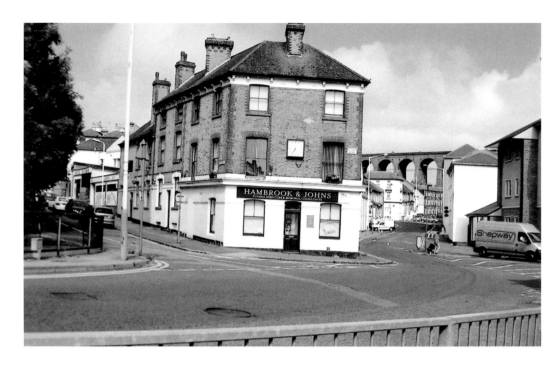

Hambrook & Johns, Funeral Directors

No. 1 Dover Road is home to Hambrook & Johns, funeral directors. To the left in the top picture is Foord Road South; to the right is Bradstone Road. The first building on the right is the clinic that was built on the old Olby's builder's merchant site. The bottom picture was taken in February 2002 and shows Bradstone Road with the Hambrook & Johns premises extending as far as the orange-painted windows, which are part of the old Salvation Army site.

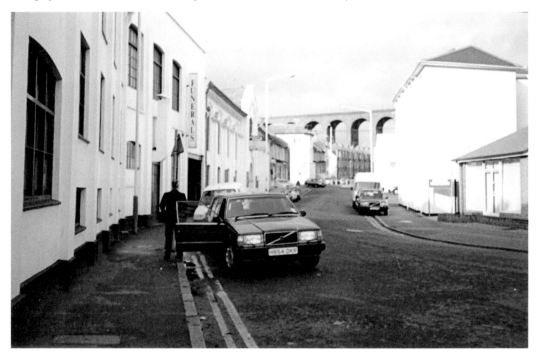

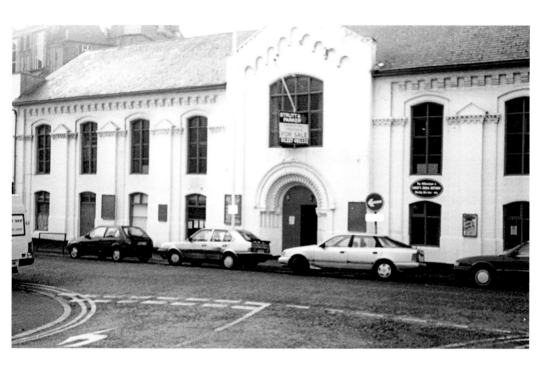

Old Salvation Army Citadel

The top picture shows the Salvation Army hall up for sale in Bradstone Road in 2002. A plot of land at the top of Archer Road and on the corner of Canterbury Road was at this time being acquired for the building of a new Salvation Army Citadel. The bottom picture shows the site of the old Co-op, which was built in 1923, overlooking the bottom of Bradstone Road. This has been a bingo hall for many years now.

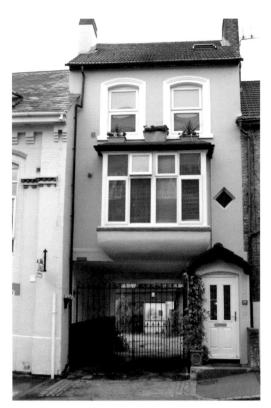

Hidden Businesses

Next door to the old Salvation Army hall is No. 17 Bradstone Road. The opening underneath the building is known as the Forge Yard; for over a hundred years carpenters and builders have occupied this yard. May & Castle were carpenters and builders, and Rolfe & Son were general smiths. Today, Ashley Light Engineering trade from there.

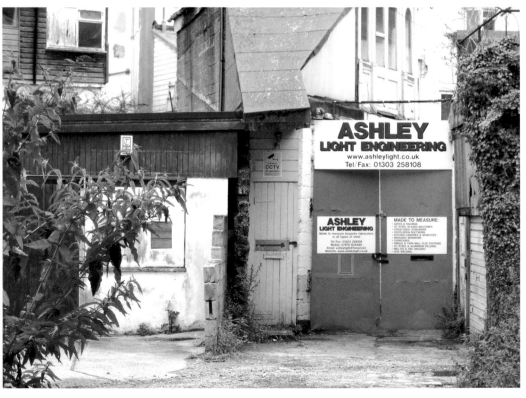

Hidden Businesses Revealed

Three houses up from No. 17 Bradstone Avenue is New Street. The first building on the left of the top picture was No. 10, where a Mrs Hopkins ran General Stores in 1949; today it is a dwelling. Nos 6 and 8 are dwellings and the tall building at the top of the road was Dunn's plumbing supplies on the corner of Foord Road South and New Street. The bottom picture, with its mismatch of buildings, was taken looking over the wooden fence on the left of the picture above. The buildings are those at the back of No. 17 Bradstone Avenue.

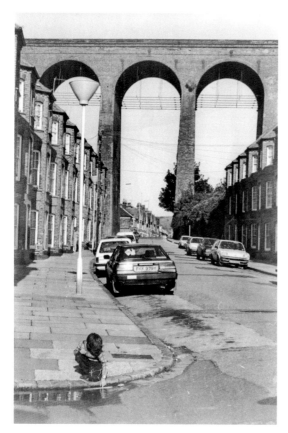

Innocence of a Child

Here we see a small child playing in a puddle on the corner of Bradstone New Road in the 1980s. Below, in 2004, we see the Foord viaduct from Foord Road on the corner of Devon Road. Barretts, the car showroom, occupies what used to be the Corporation yard where steamrollers were kept. As a child, I loved to watch and hear the steamrollers clanking down the road with the steam coming out all over the place.

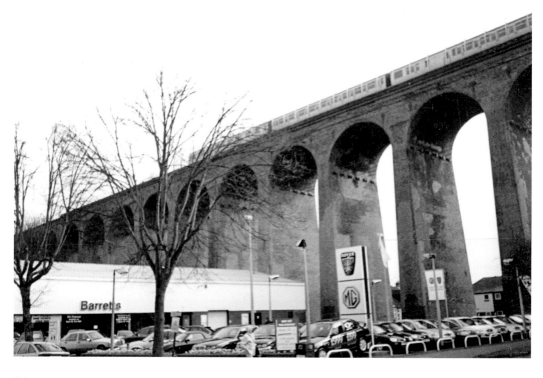

From Scrub Land to an Estate

This is the field at Shepway Close. Planning permission has been sought to have houses and flats built on the old Dawson Road Youth Club site. Eighty per cent of the field has to remain as an open site for people to enjoy, as laid down in a covenant made in 1841 by Lord Radnor and Viscount Folkestone. The top picture shows the fenced-off area where the gas holder stood. In the bottom picture, the site is being surveyed as workmen prepare to do the groundwork for the flats and houses that will become Peto Close.

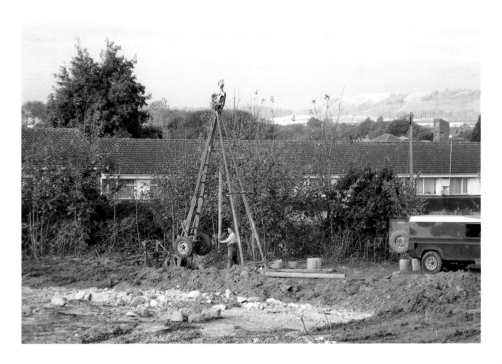

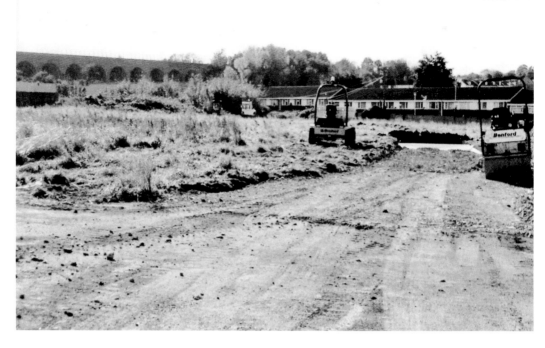

Groundwork for Peto Close

In 2008, a roadway is being made through the old youth club site to facilitate the coming months of building the Peto Close project for a housing association. In the colour photograph, heavy plant has arrived on the site and is clearing away debris so groundwork can begin.

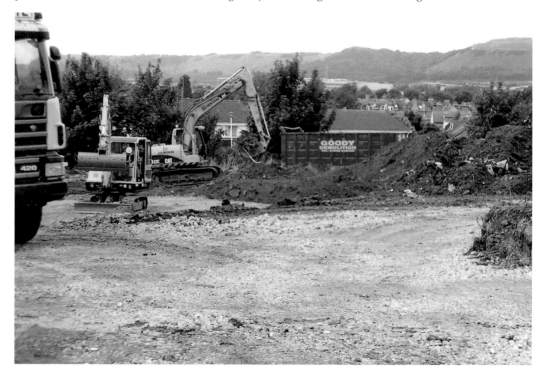

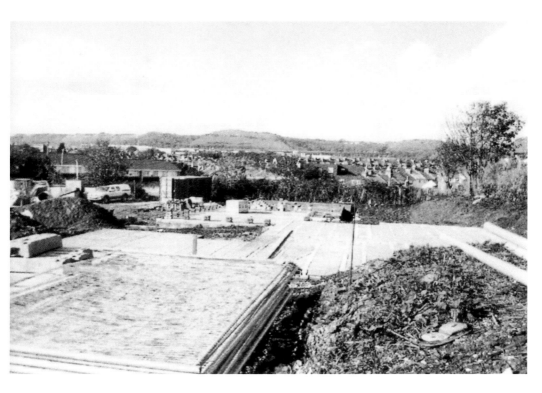

Side View of Peto Close
Above we see the groundwork nearing completion at the Peto Close estate works in 2008. Below is the side view of the completed flats.

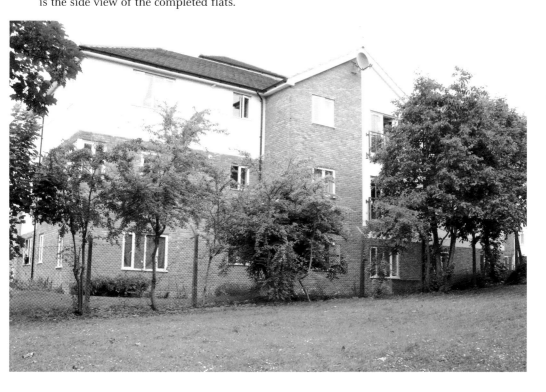

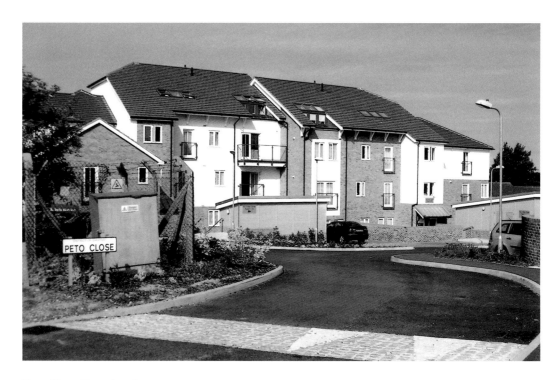

Peto Close Completed

The top picture was taken eight months after the completion of Peto Close in October 2009; there are thirty flats. The bottom picture was taken from Shepway Close; it shows the car park and four of the seven houses on the new estate.

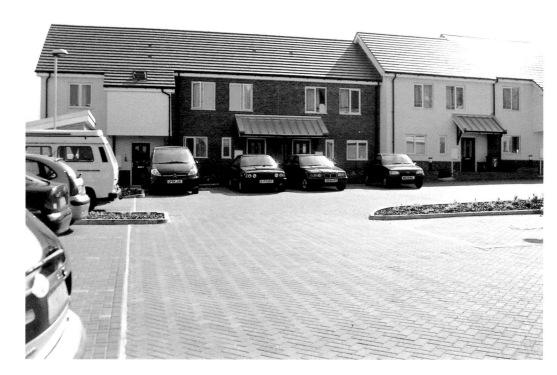

If You Belong to Us, Why Are You Fenced Off?

The top picture is of the Key Scheme building in 1999, before the fire that destroyed it, and of the field that Mundella School on Blackbull Road used for sports, which was always nicely kept. The bottom photograph is of the same field in 2011; it was taken from the entrance in Shepway Close where the youth centre was. On the left of the picture, the white-painted buildings are the Peto Close estate; the other houses ahead are part of Shepway Close. The field, although fenced off, is often broken into by cutting holes in the wire fence. Rubbish is then dumped here and dog walkers also like to use the area. When it gets really bad and complaints are made, the fence is repaired and the rubbish cleared.

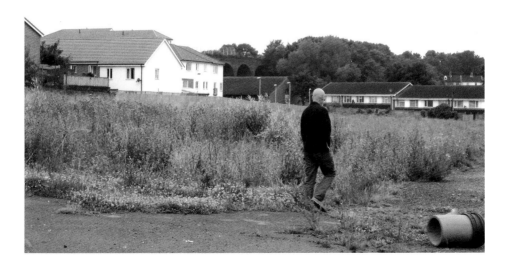

Acknowledgements

My grateful thanks go to my husband for helping me with the photography and for his patience and understanding, especially in the final months of putting this book together. The help of my son Jon and daughter Karen has been invaluable. They have shown great patience with me during the twelve years it took to put this book together, forever correcting various issues I had. Thanks also to my grandchildren Ricky and Amy, who feature in my pictures.

Alan Taylor supplied some older photos to help make the book a bit more interesting and Martin Easdown and Linda Sage offered valuable help and advice. Appreciation also goes to various friends for their help and suggestions and support in putting this book together.

Lastly a very big thank you to the staff in the heritage room at the Folkestone Library for their encouragement, saying that if our heritage is not recorded, as it is disappearing, then it is lost for all time. I am grateful for their help in supplying photographs and to the staff who have since retired that helped and supported me during this time: Pauline, Sheila, Pat and Rob.

Now the book has been completed, everyone concerned can heave a big sigh of relief at last!

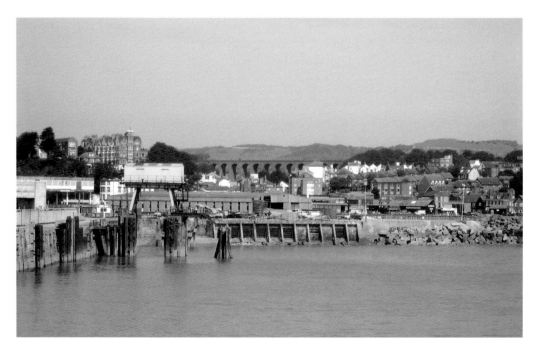

Foord Viaduct
A view of the Foord viaduct from the upper walkway of the harbour pier.